Bird Coloring Book 1

by RJ & IrisBenjamina
Photos by Chris R Johnson
Copyright 2019. All rights reserved.

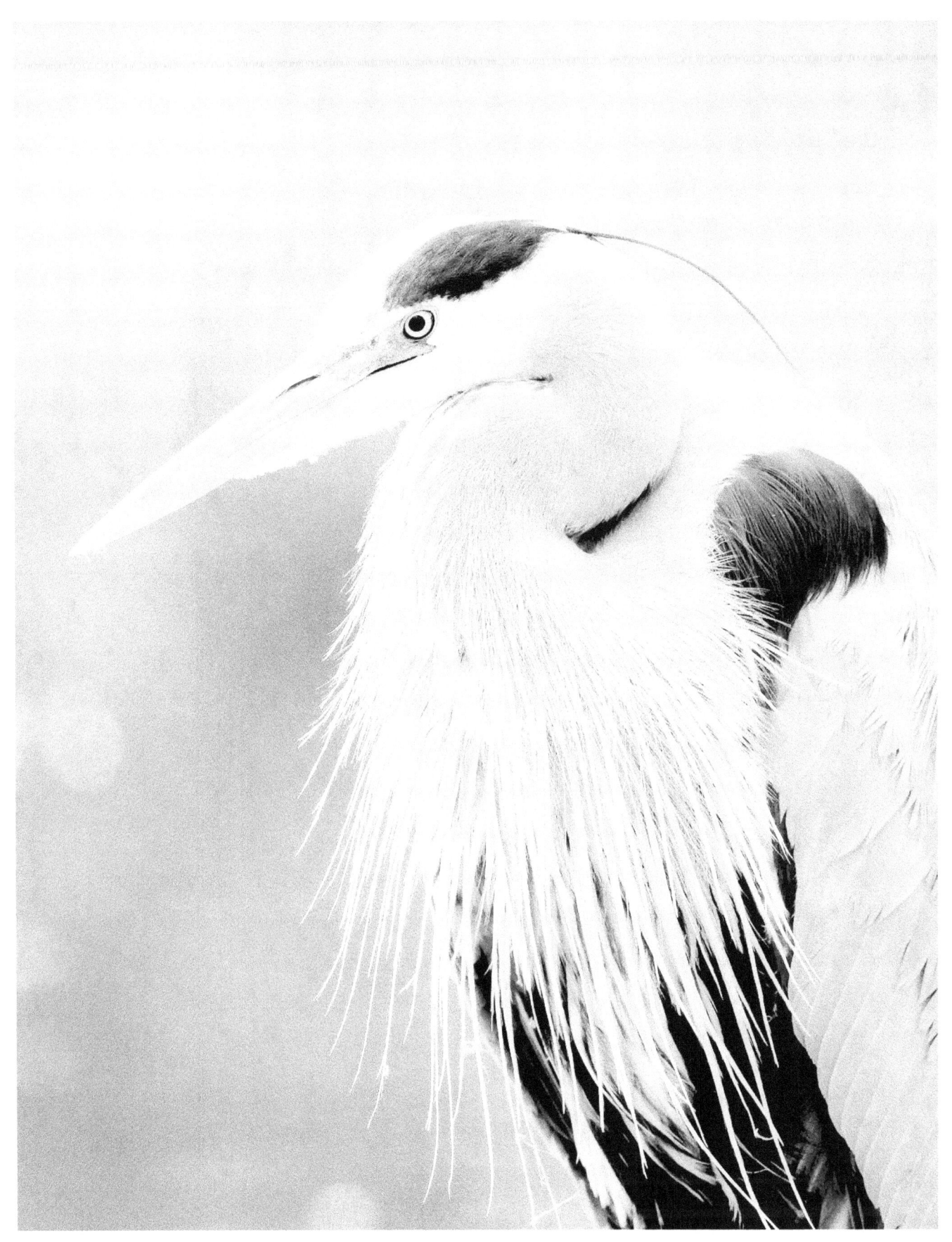

Great Blue Heron

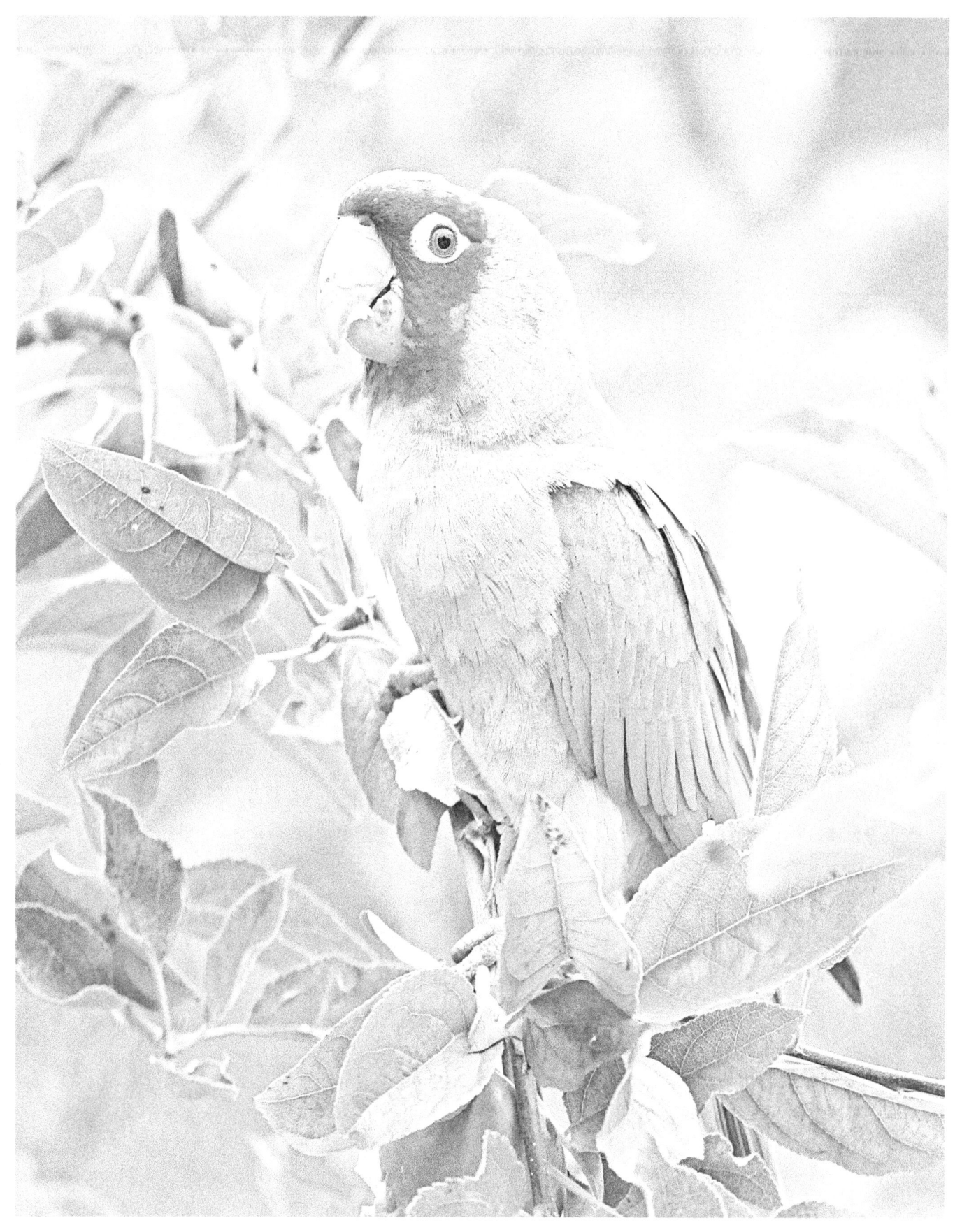

Wild Mitred Red-masked Parakeet

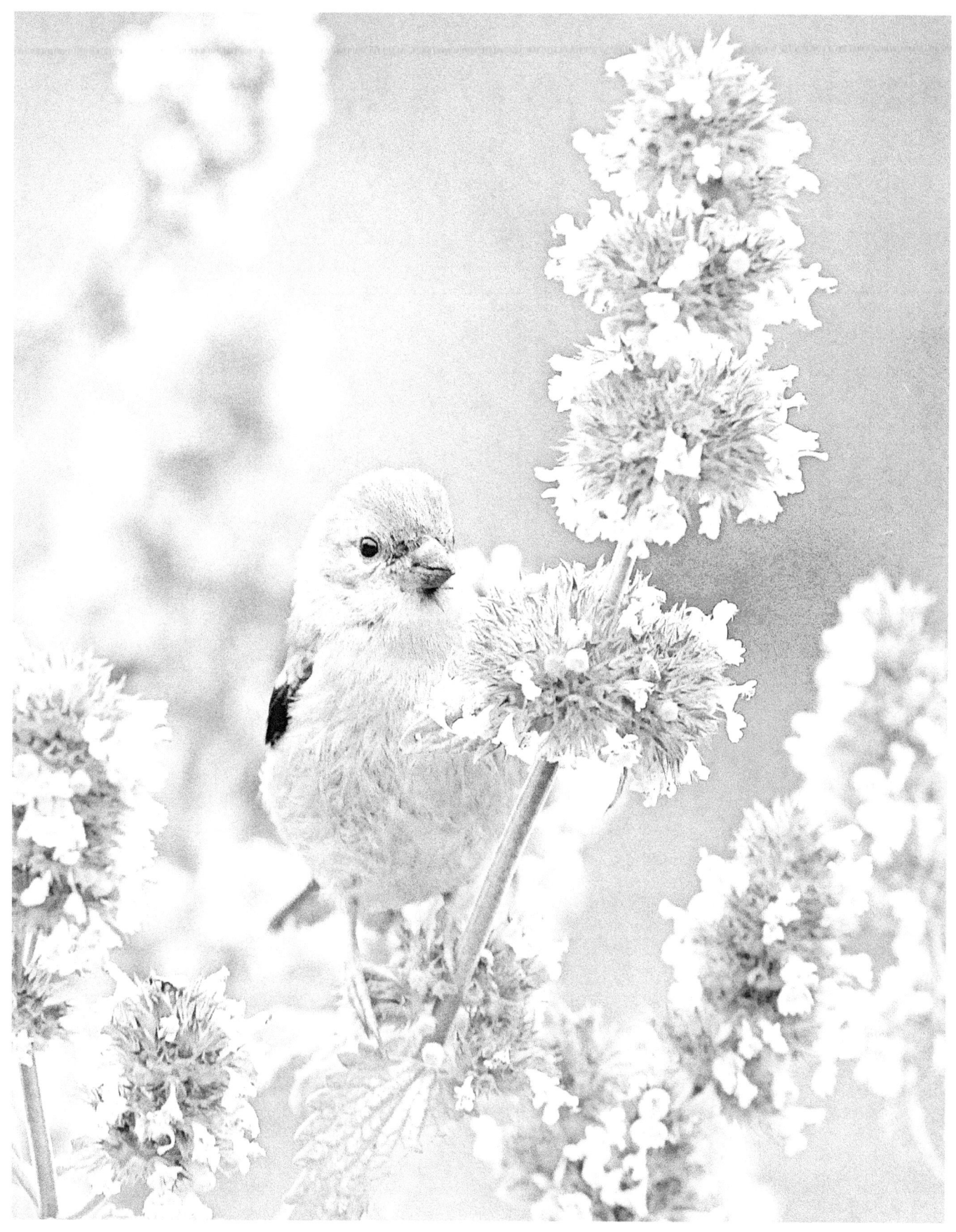

American Goldfinch

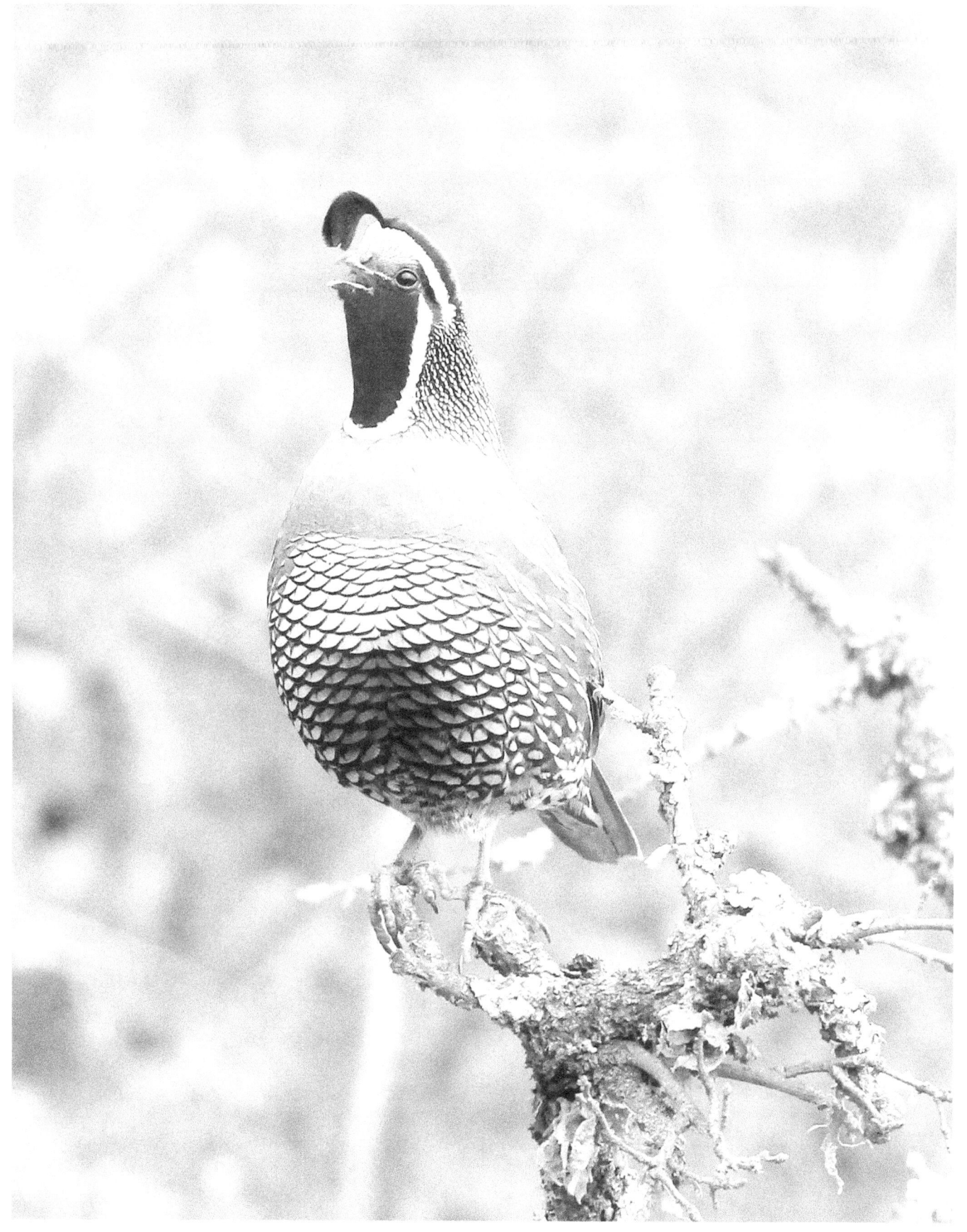
California Quail

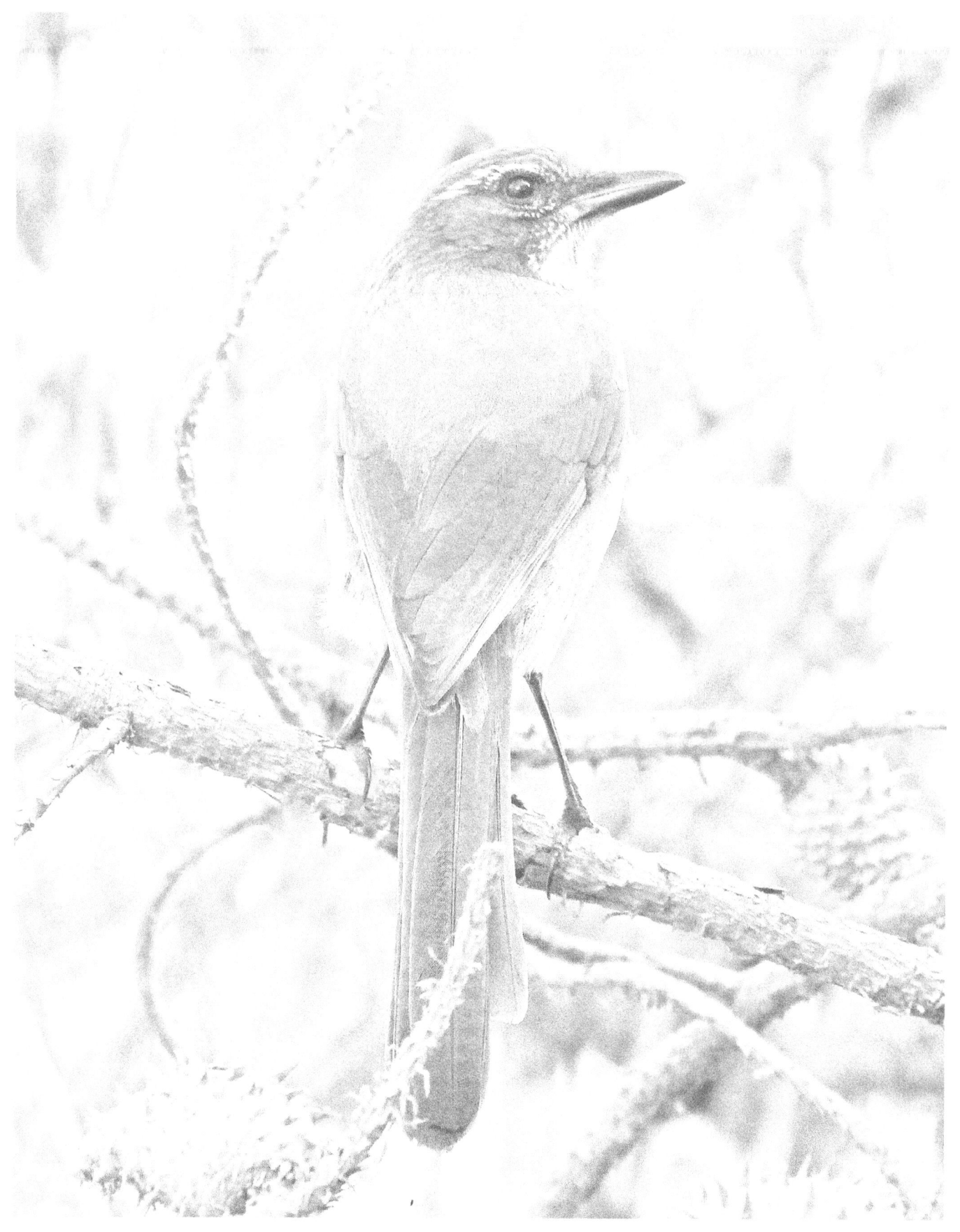

Scrub Jay

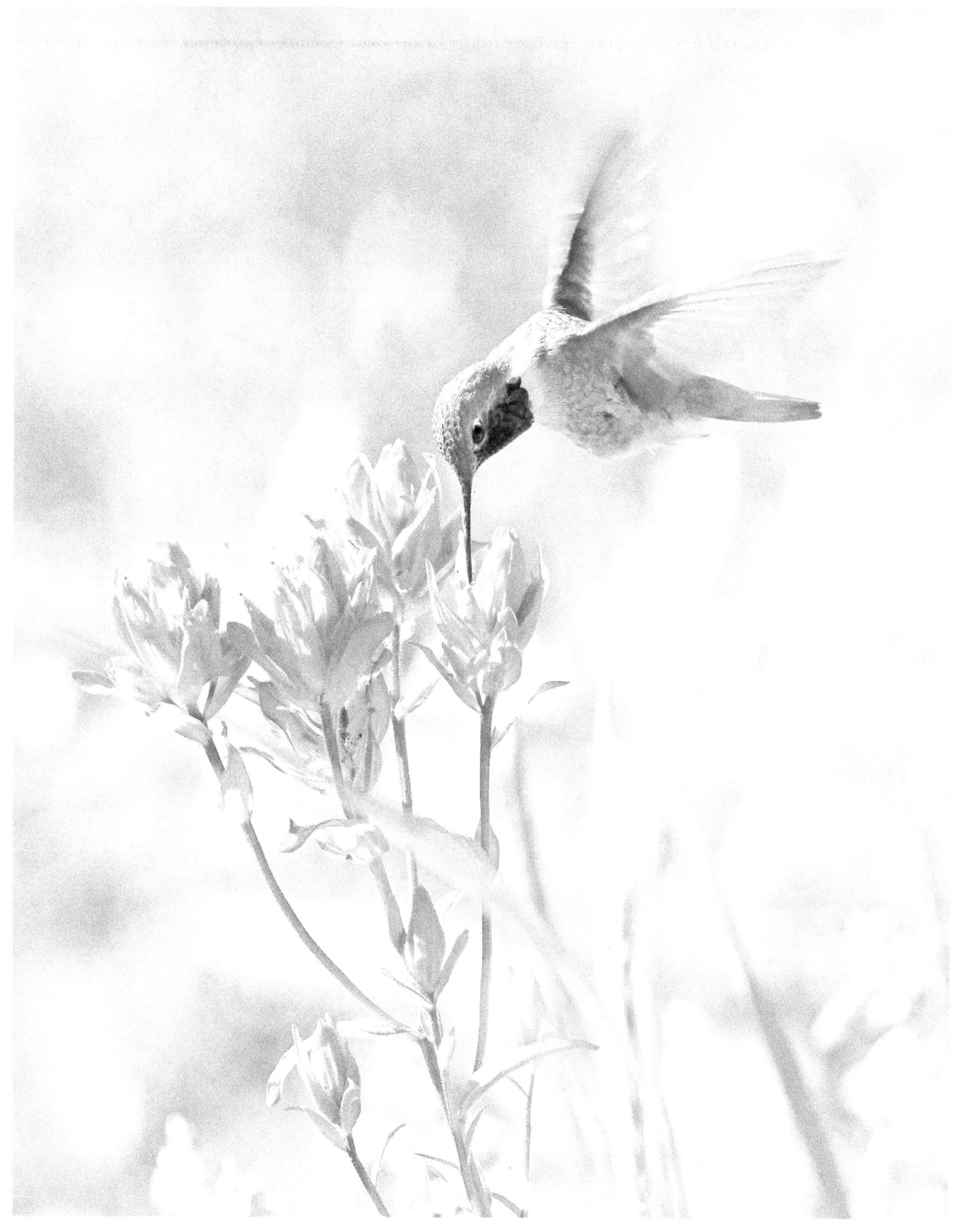

Broad-tailed Hummingbird

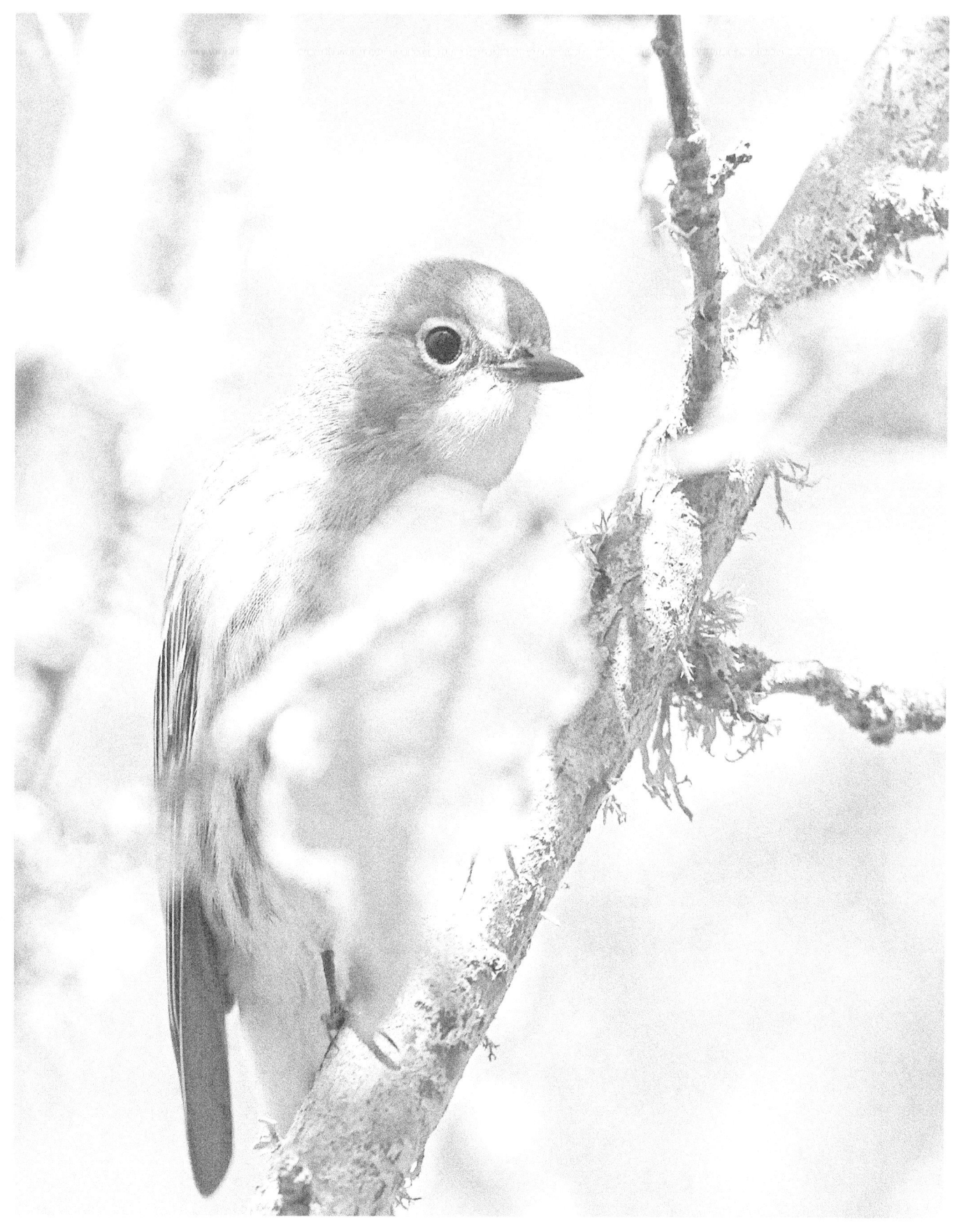

Yellow-rumped Warbler

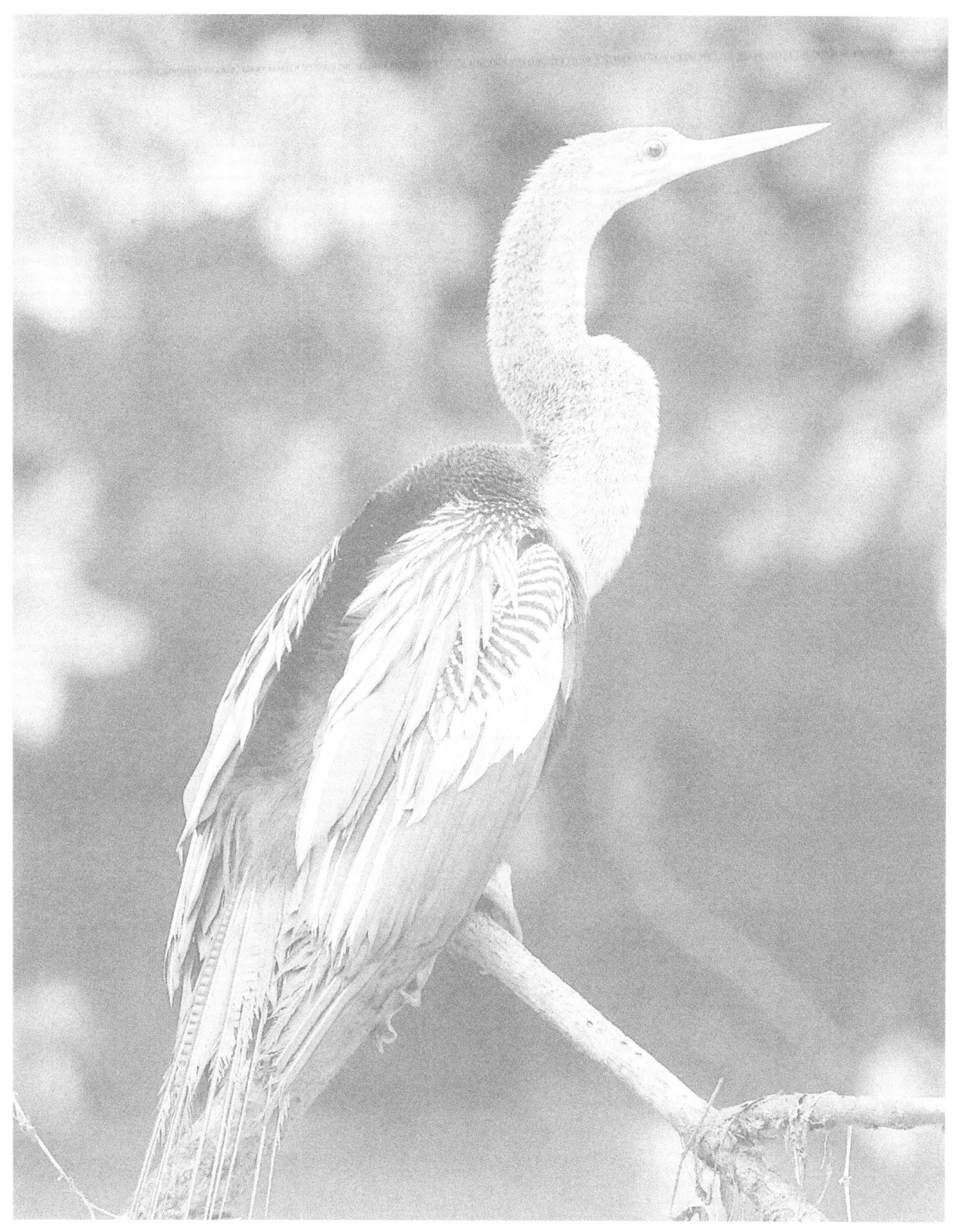

Anhinga

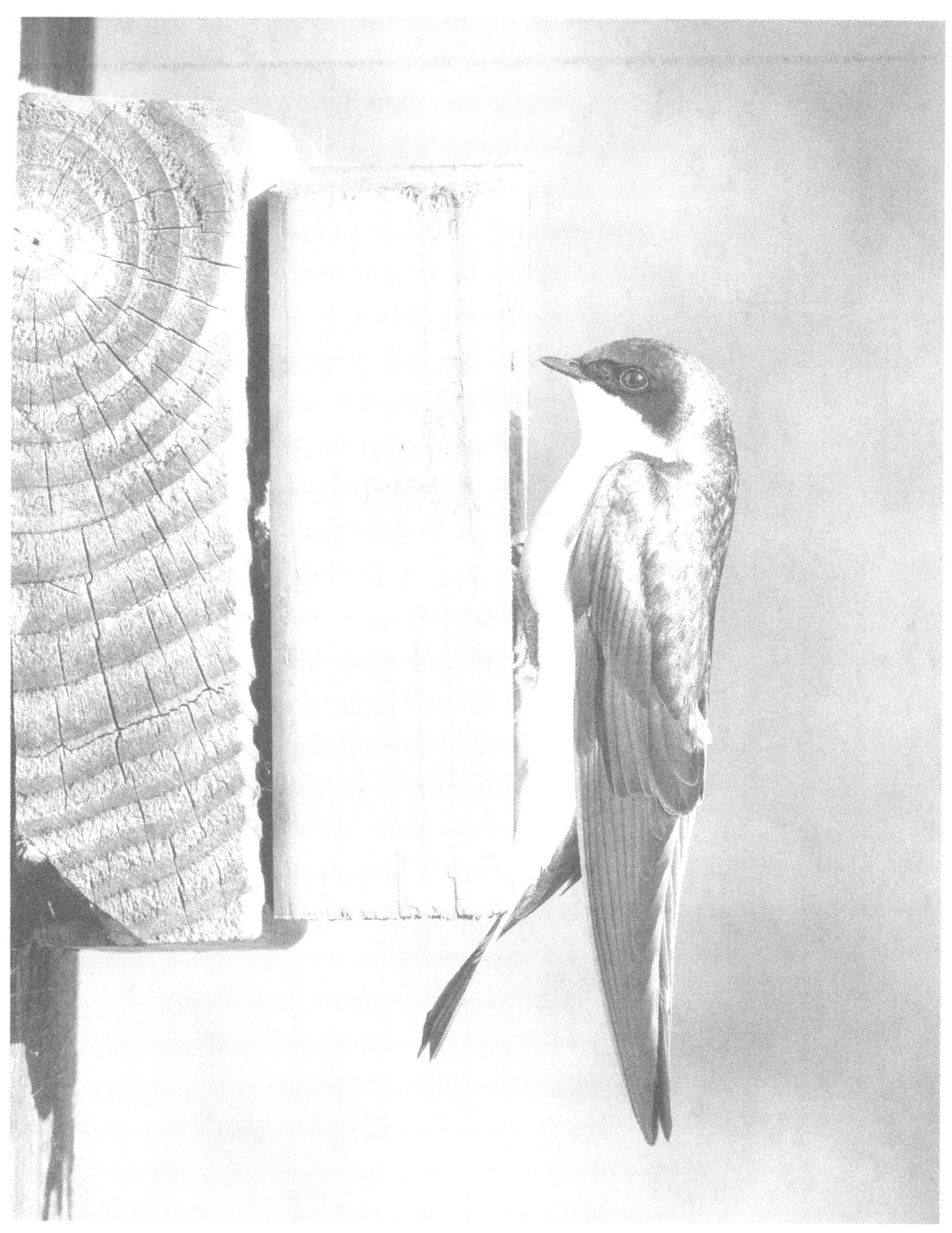

Tree Swallow

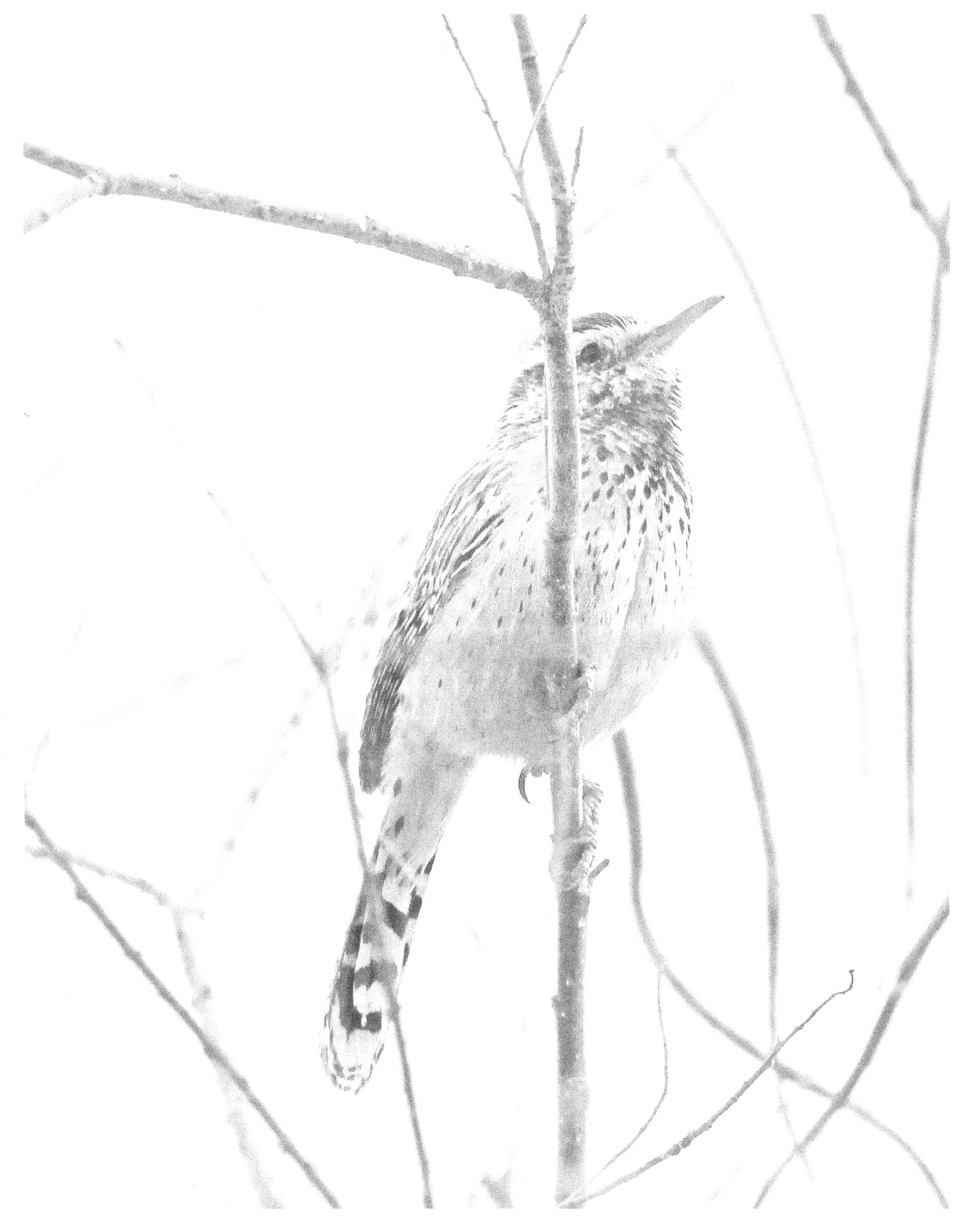

Cactus Wren

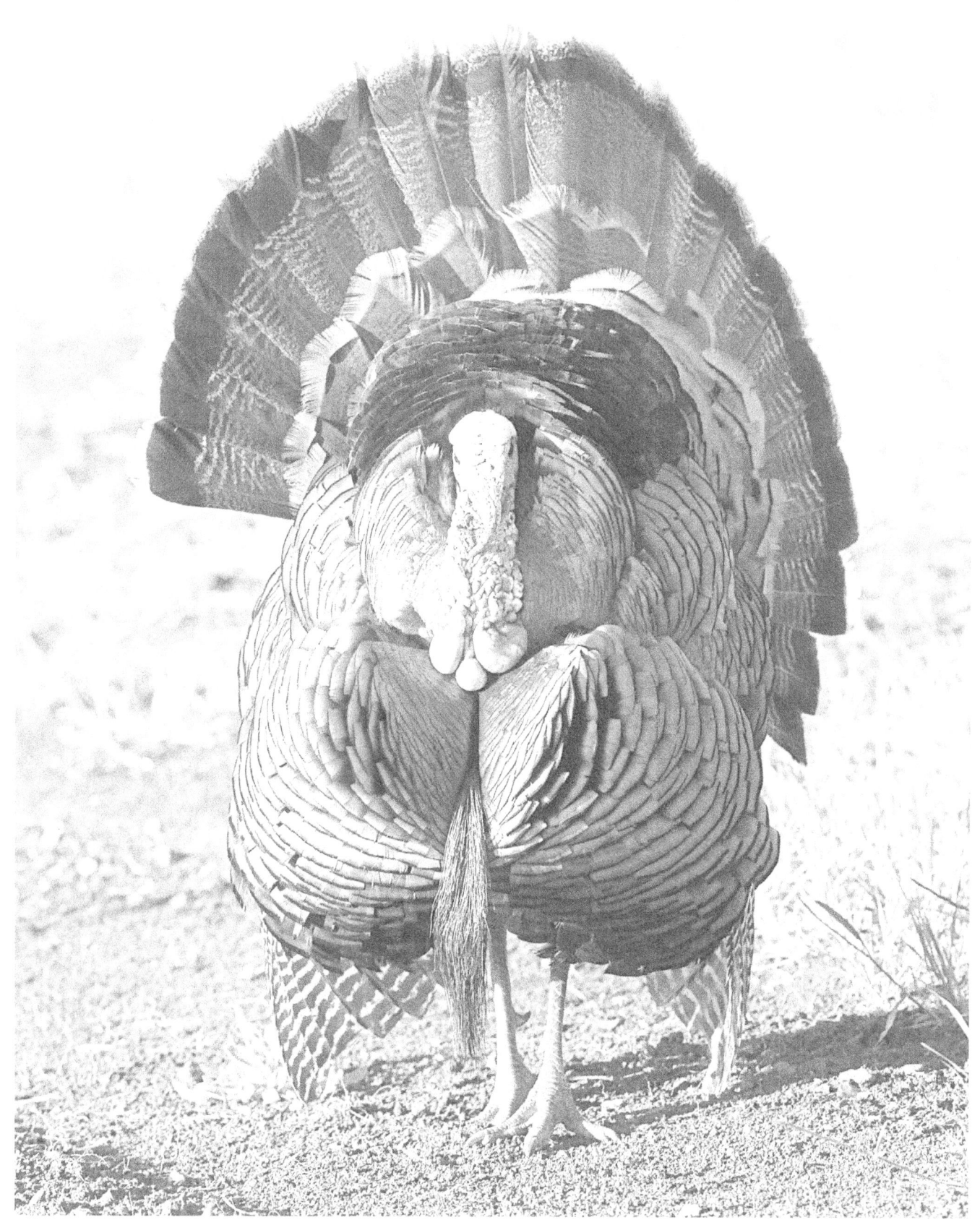
Turkey

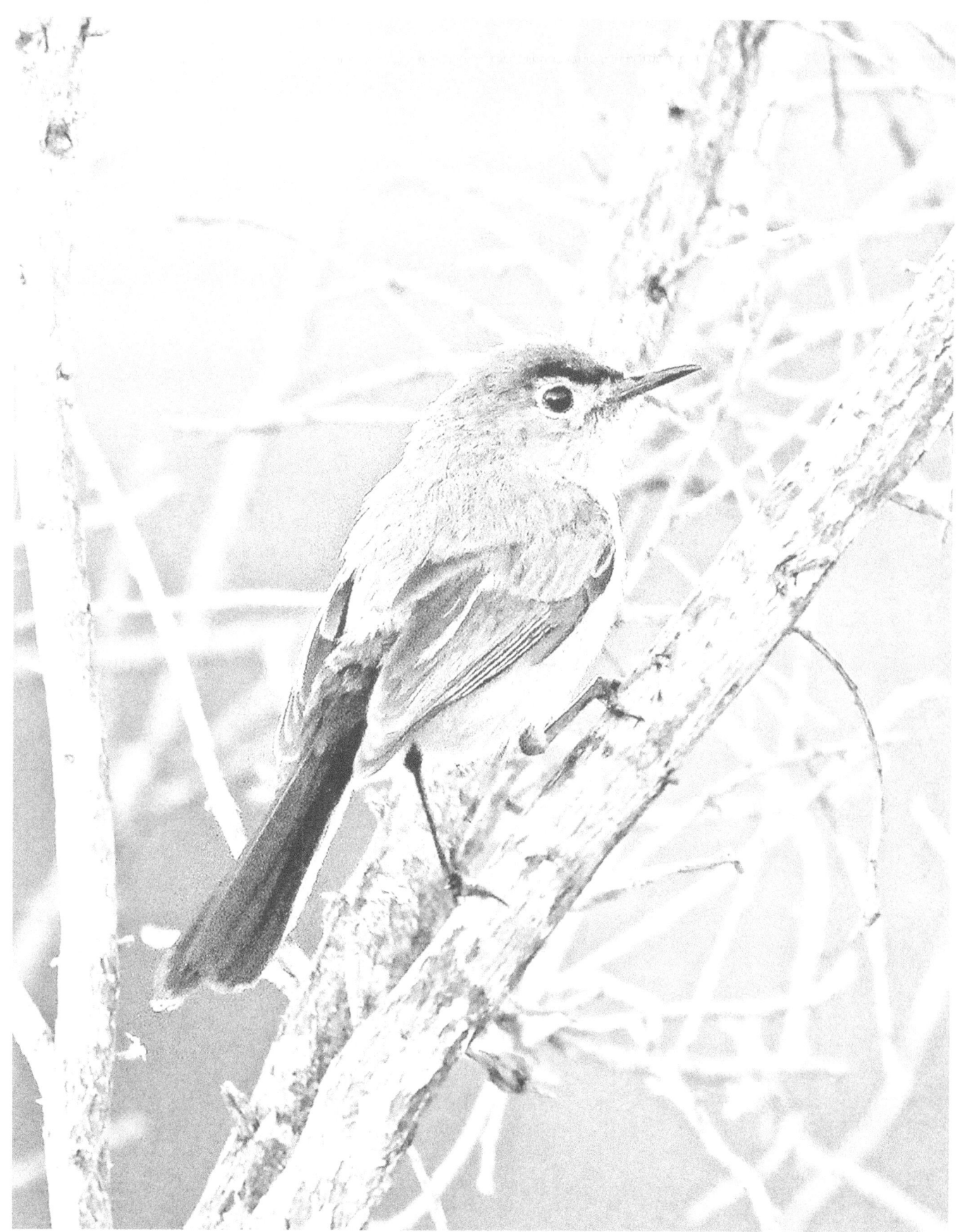
Blue-grey Gnatcatcher

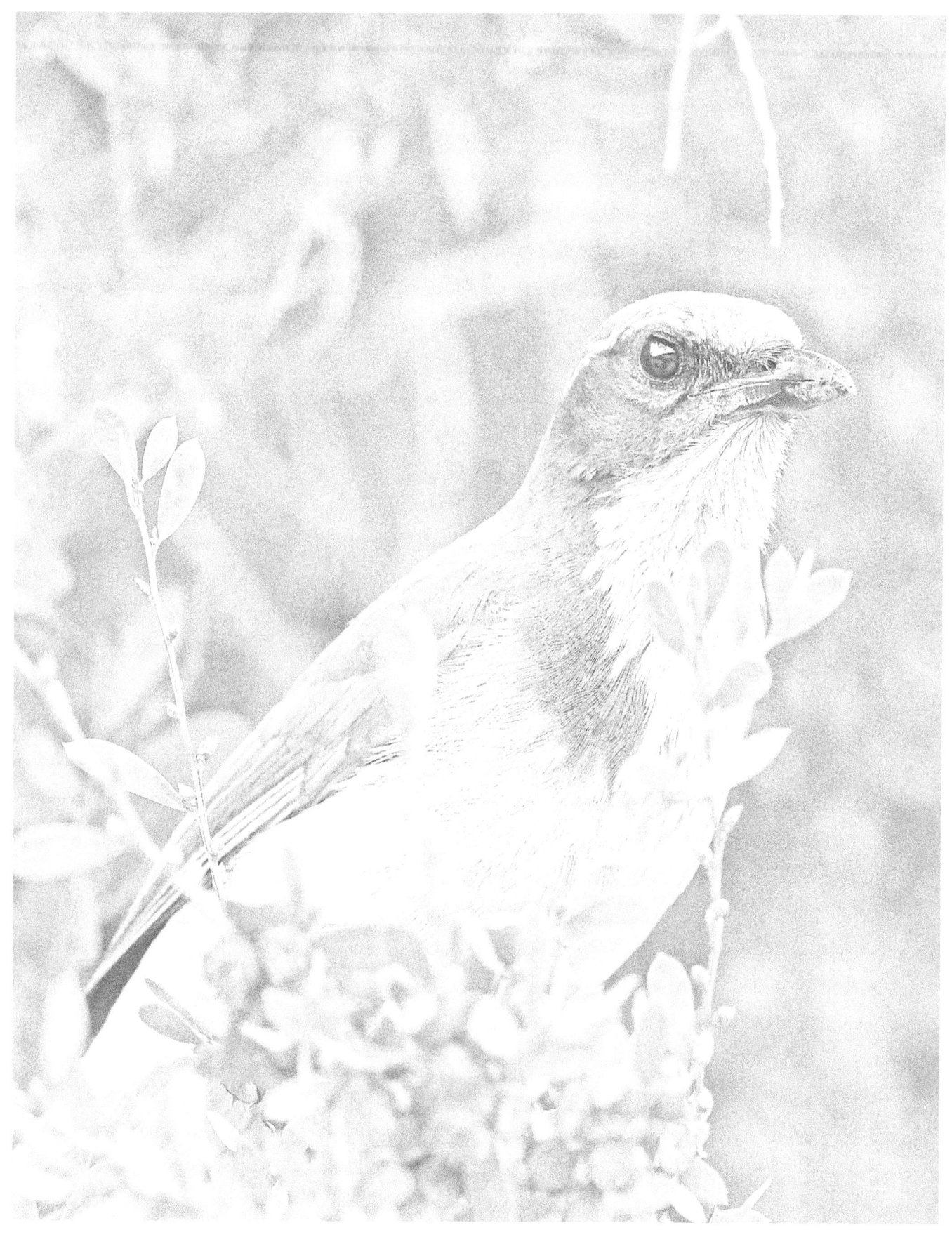

Scrub Jay

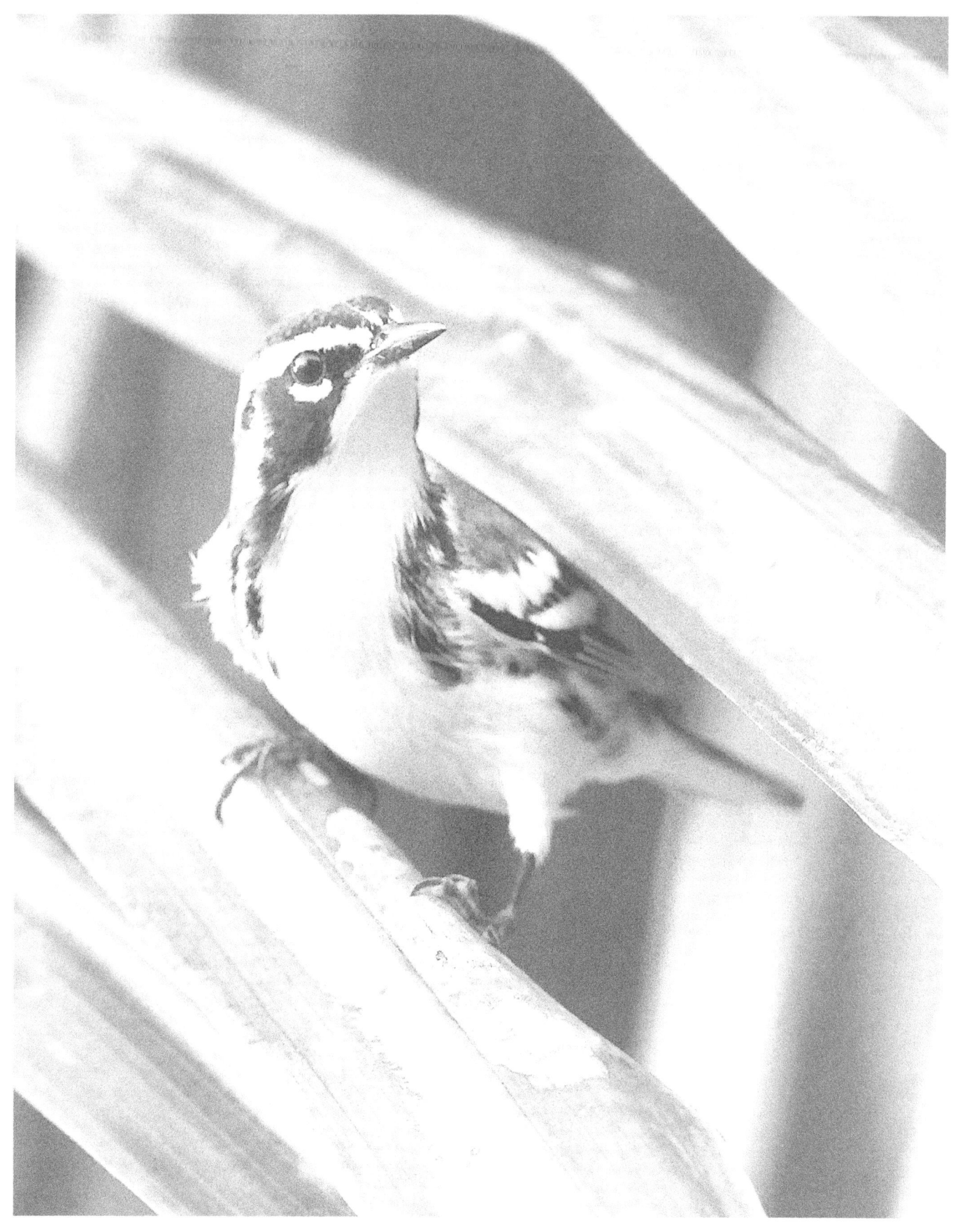
Yellow-throated Warbler

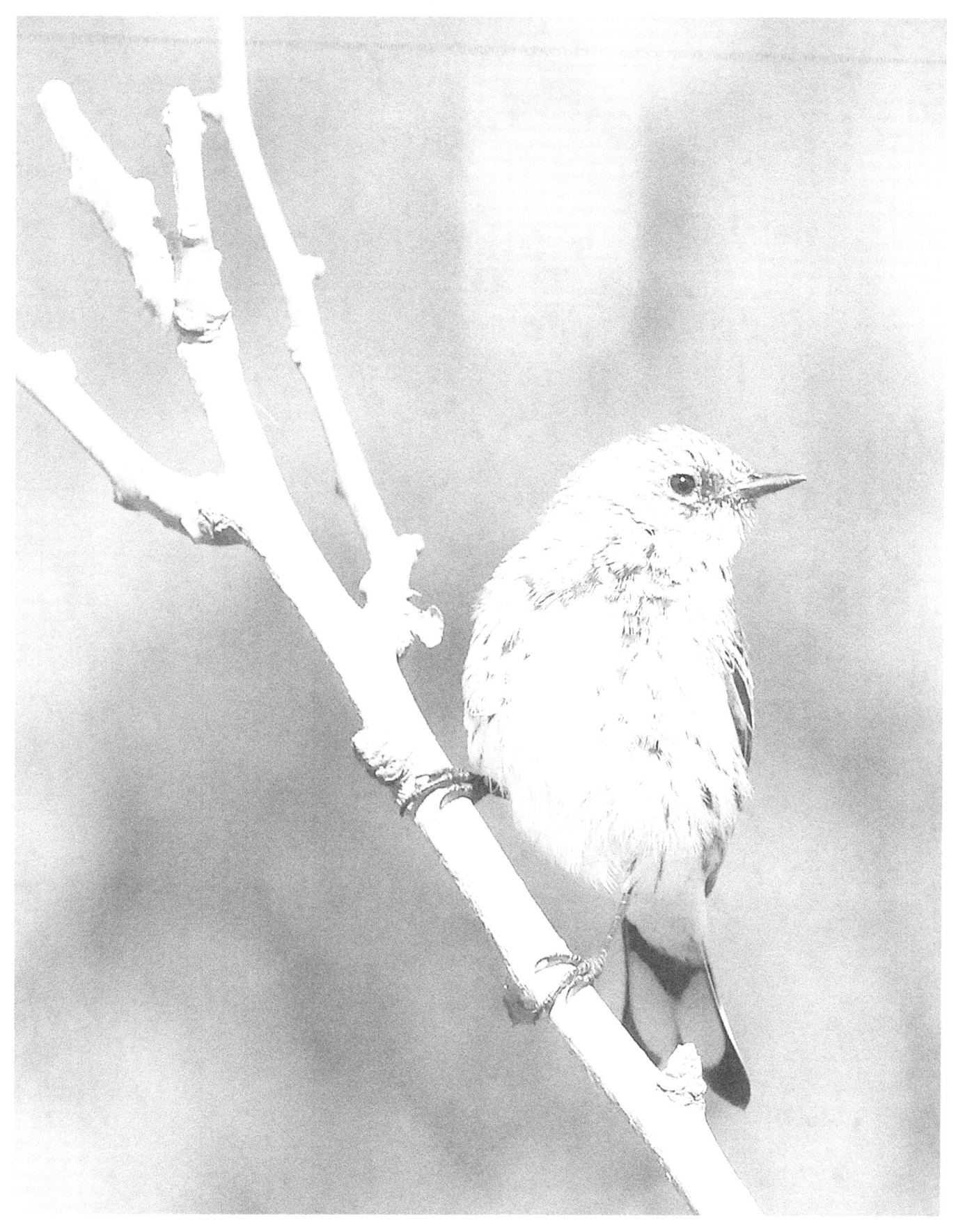

Yellow-rumped Warbler

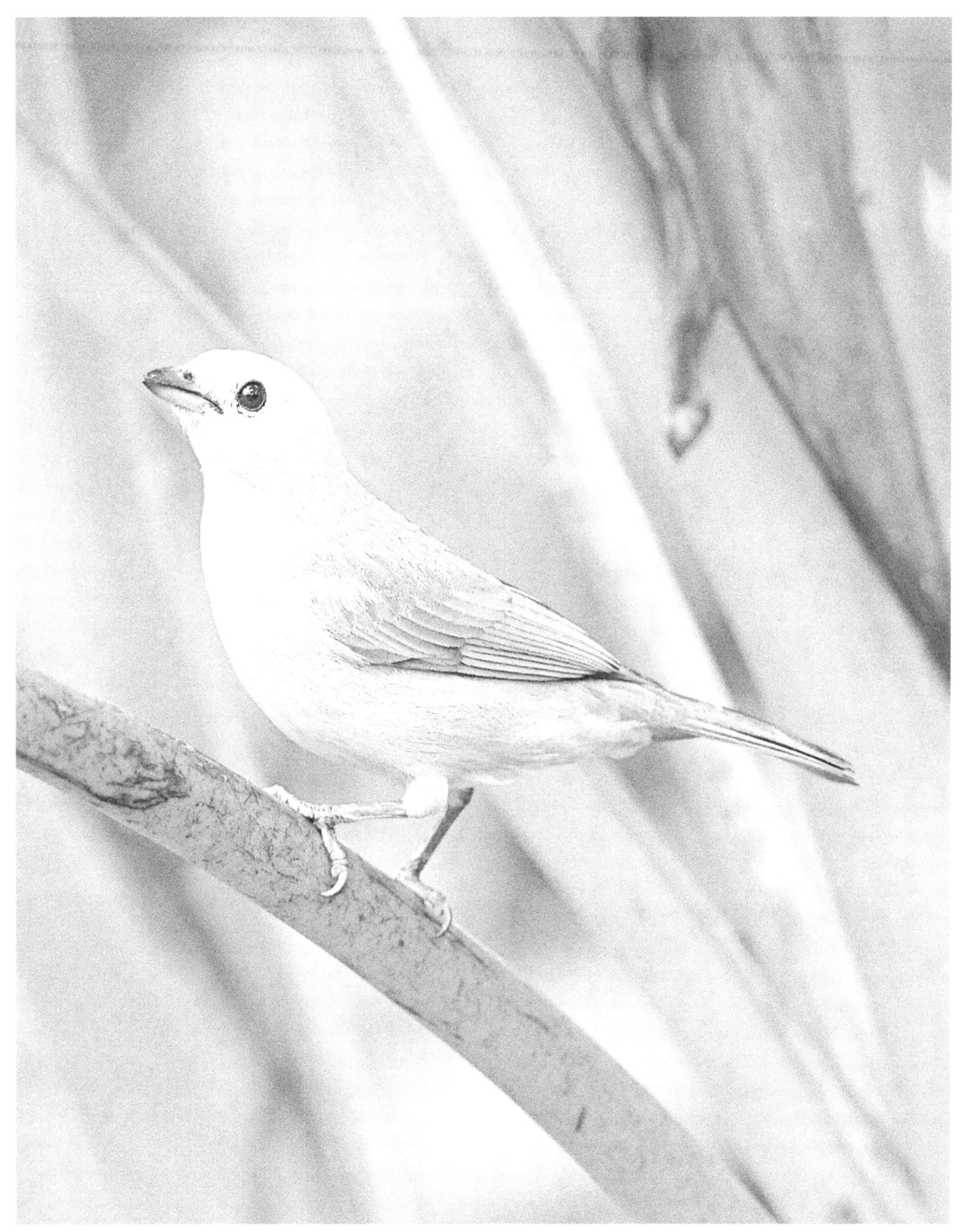

Blue-grey Tanager

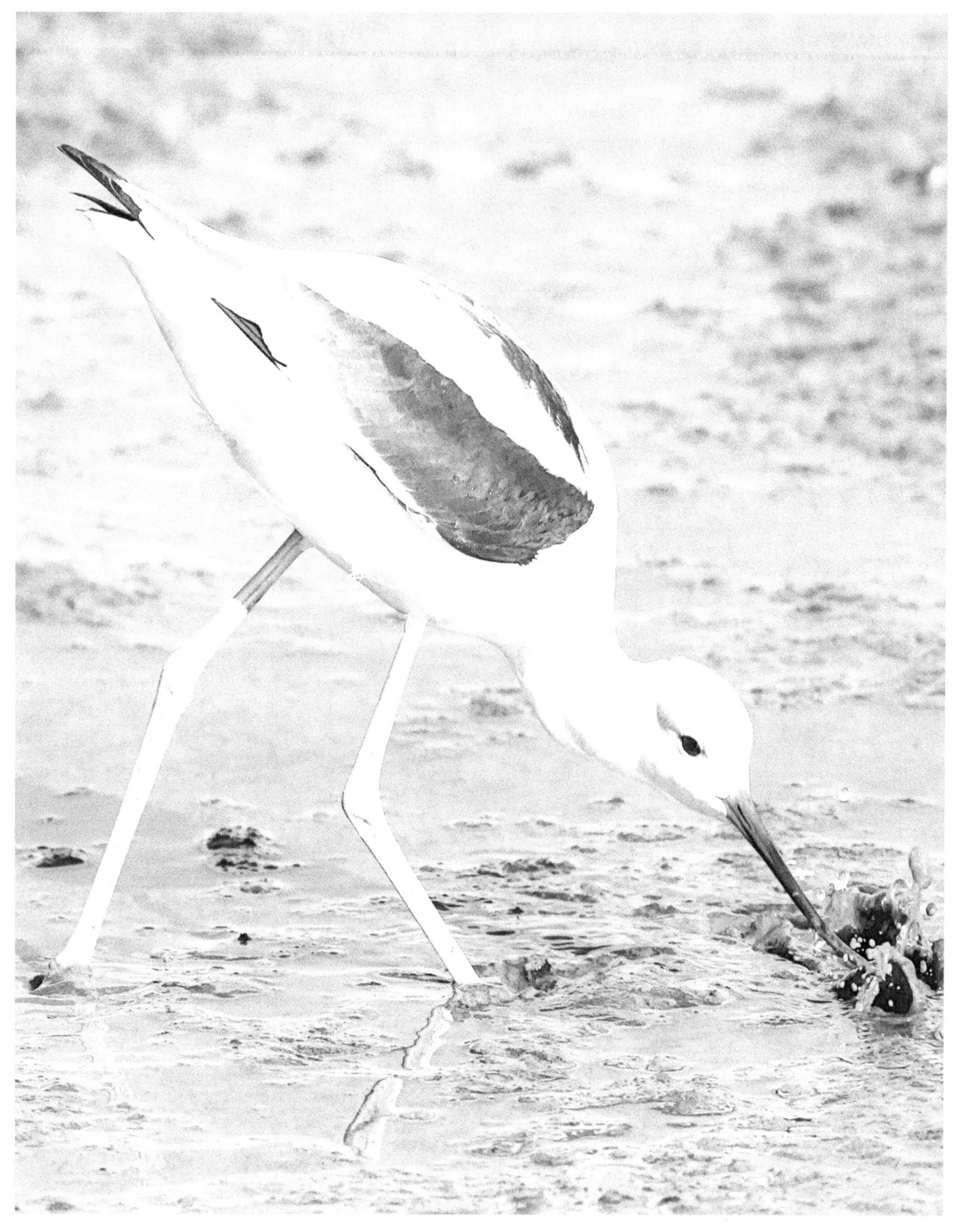
American Avocet

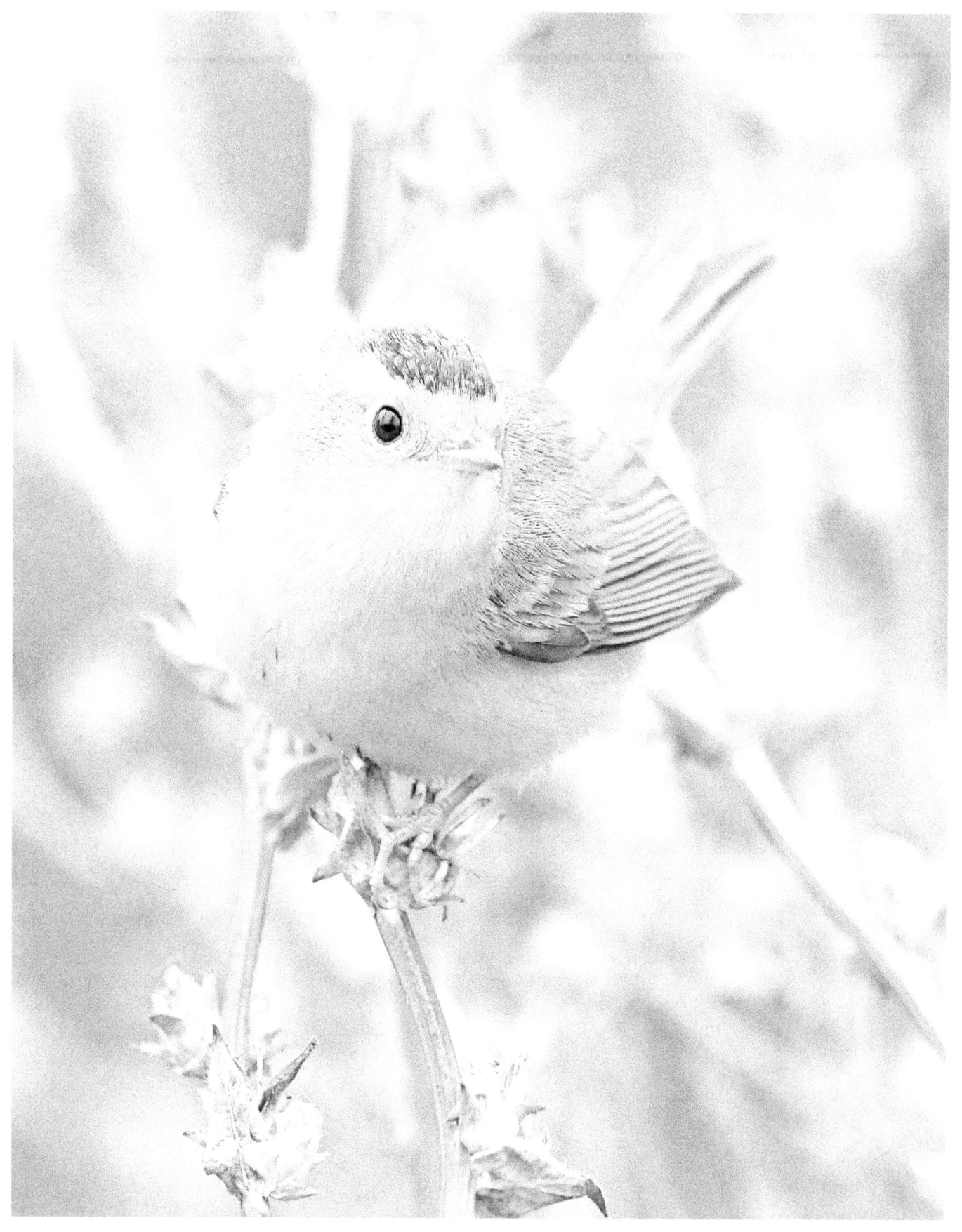
Wilson's Warbler

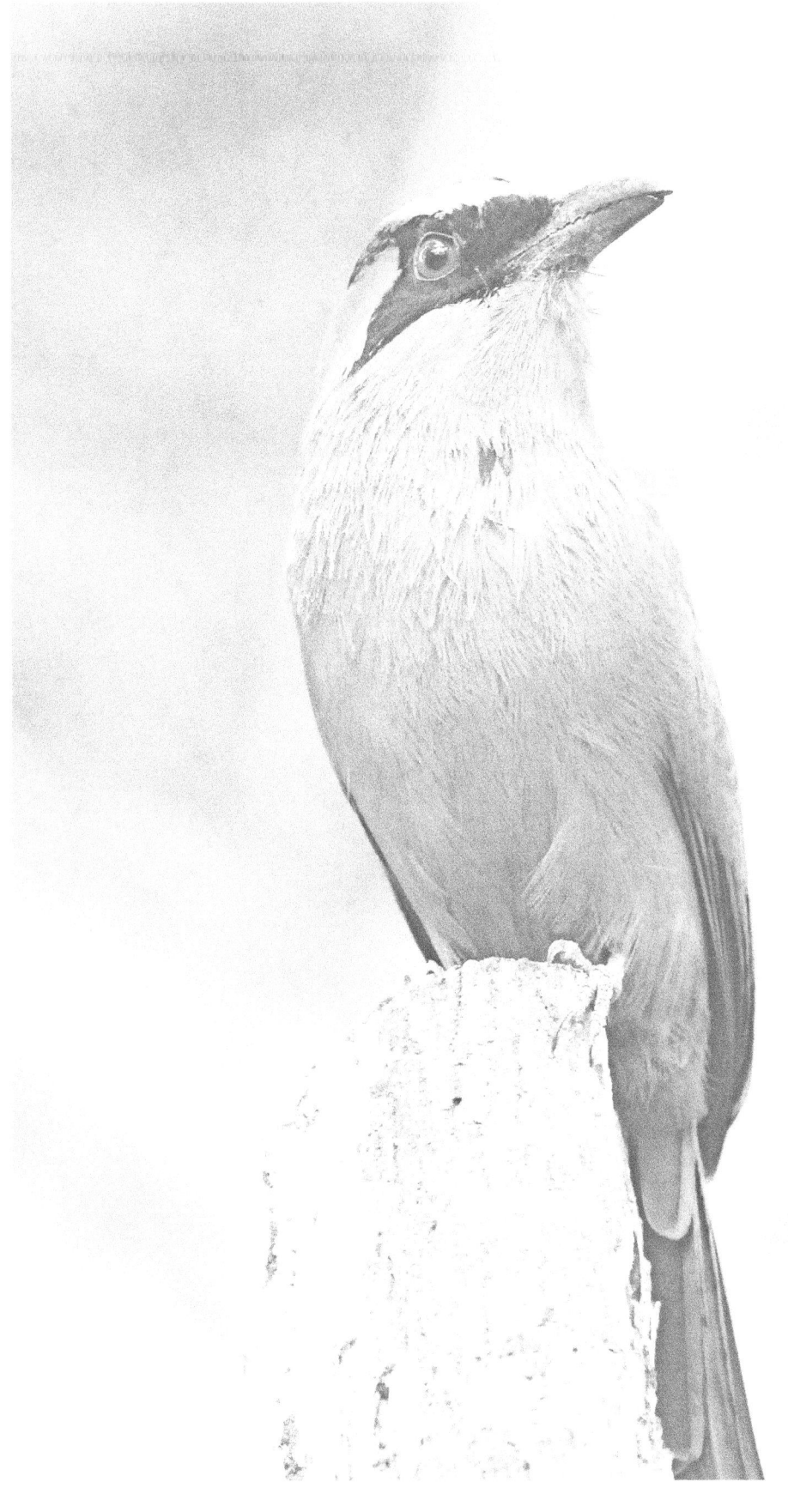

Blue-crowned Motmot

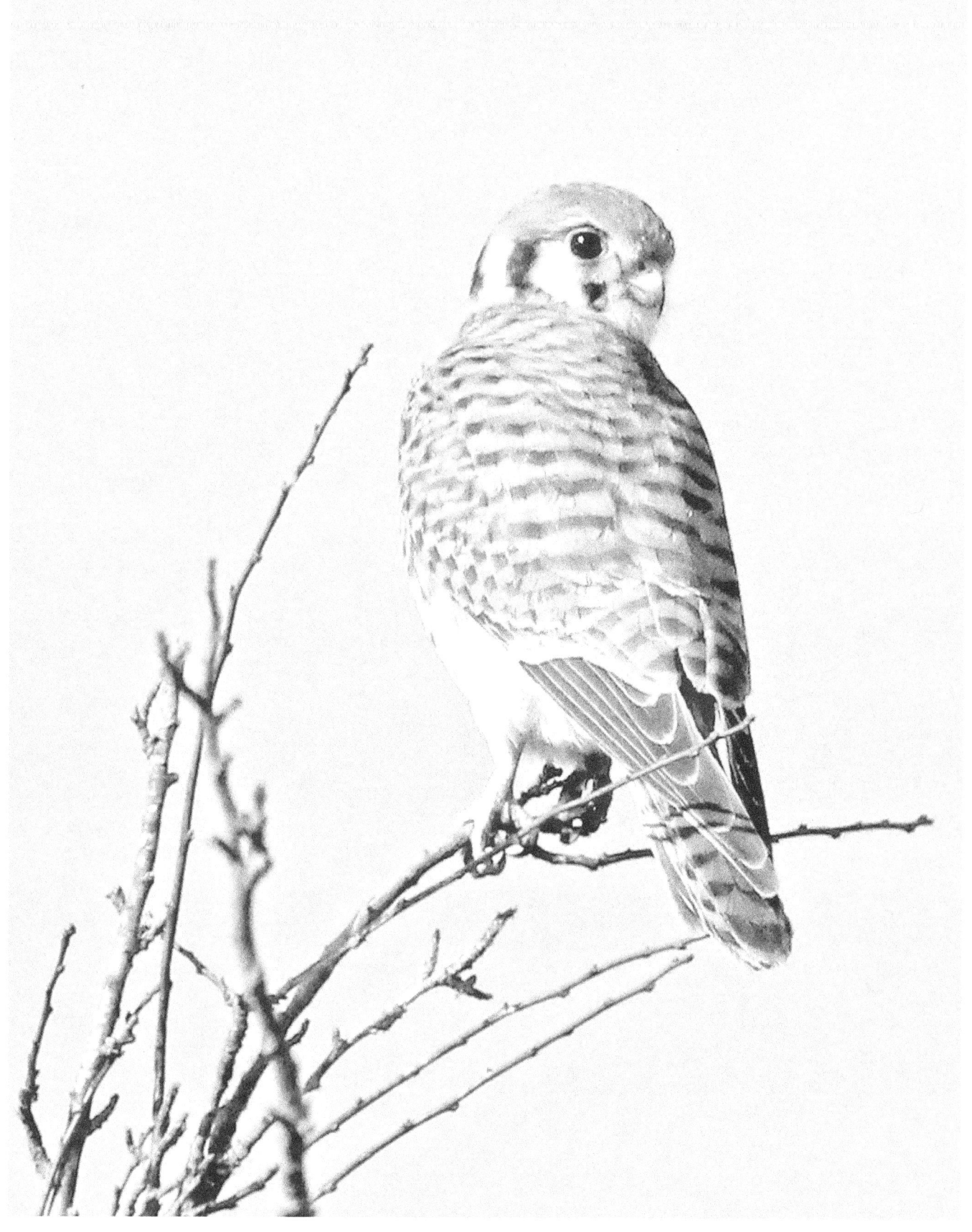

American Kestral

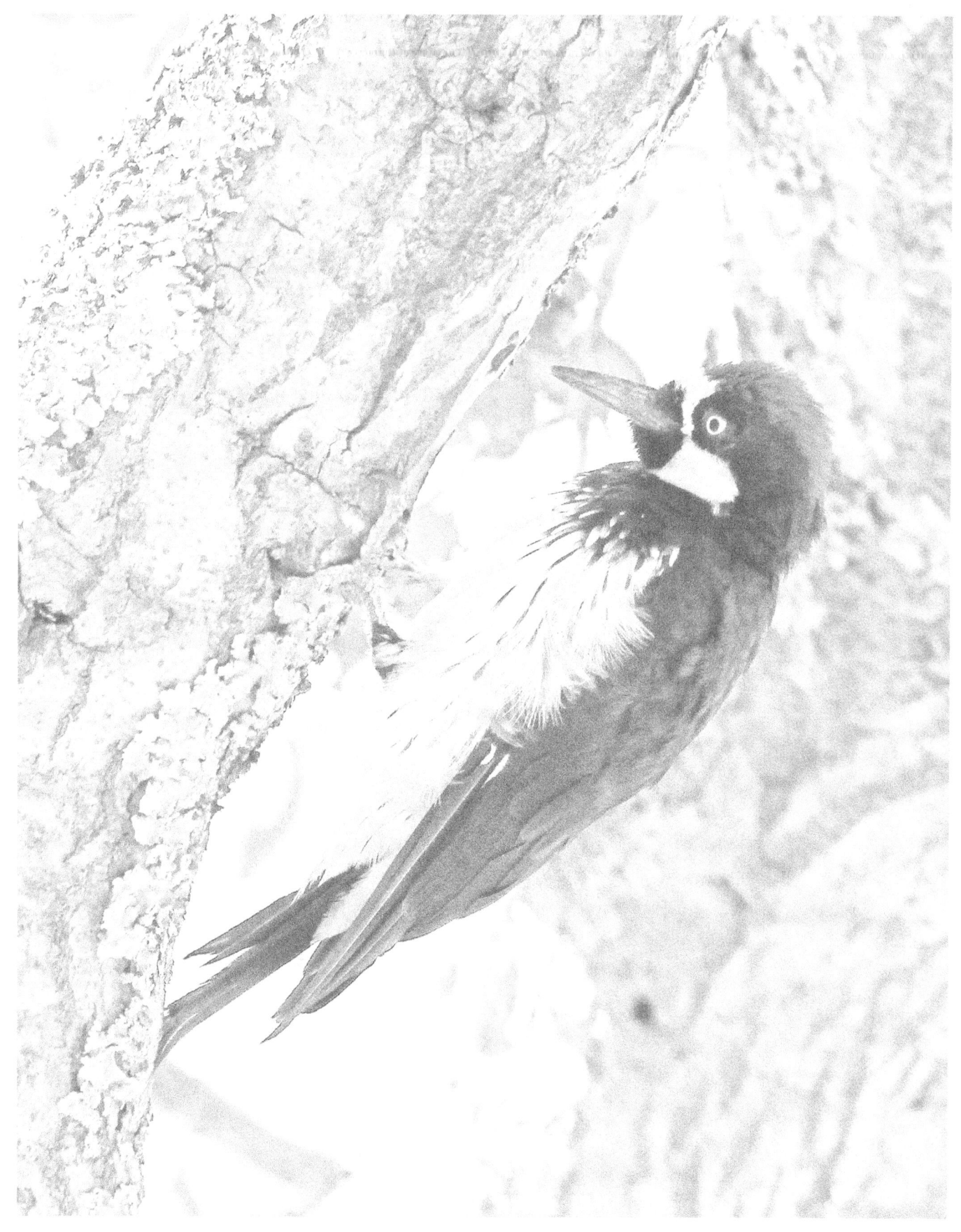

Acorn Woodpecker

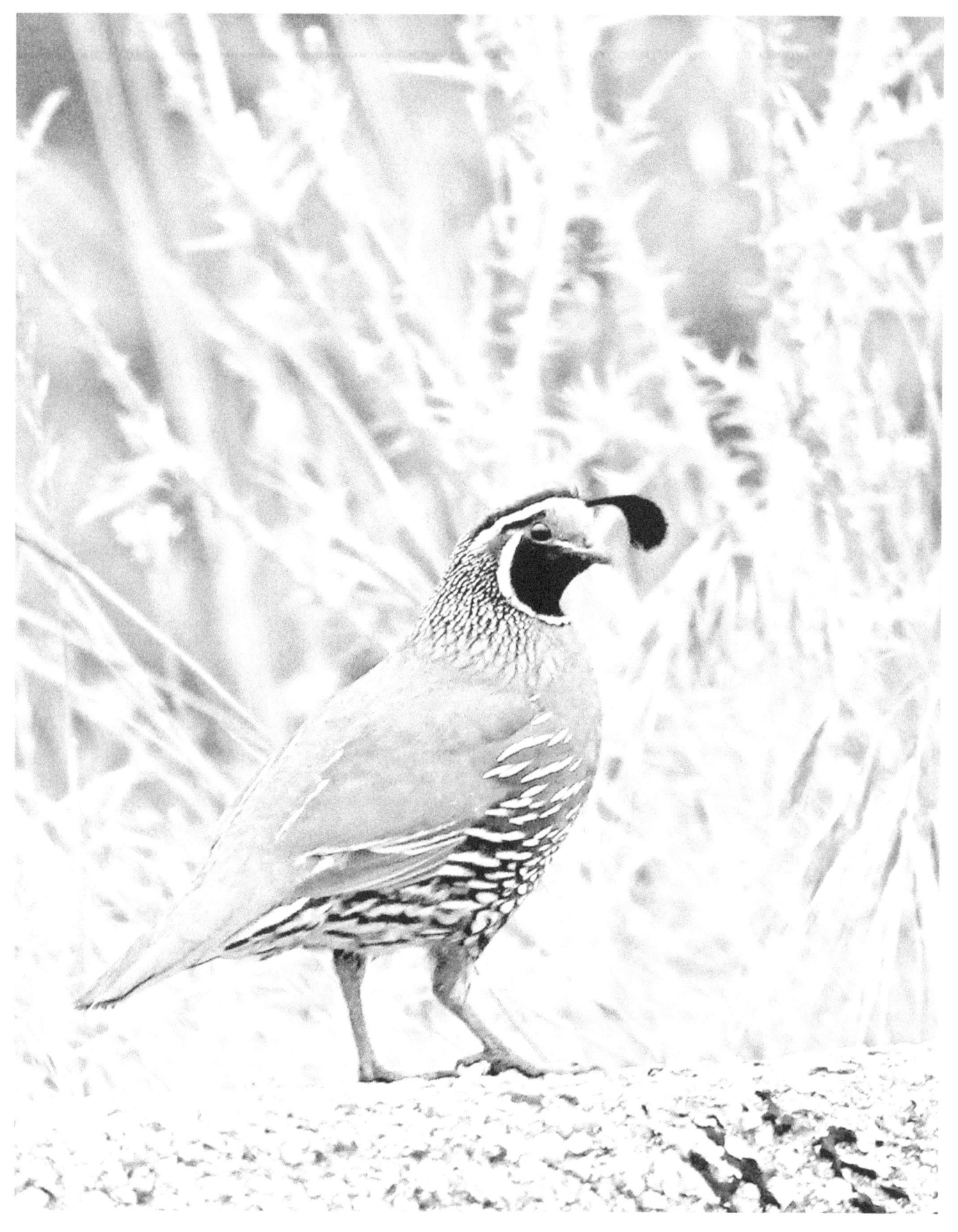
California Quail

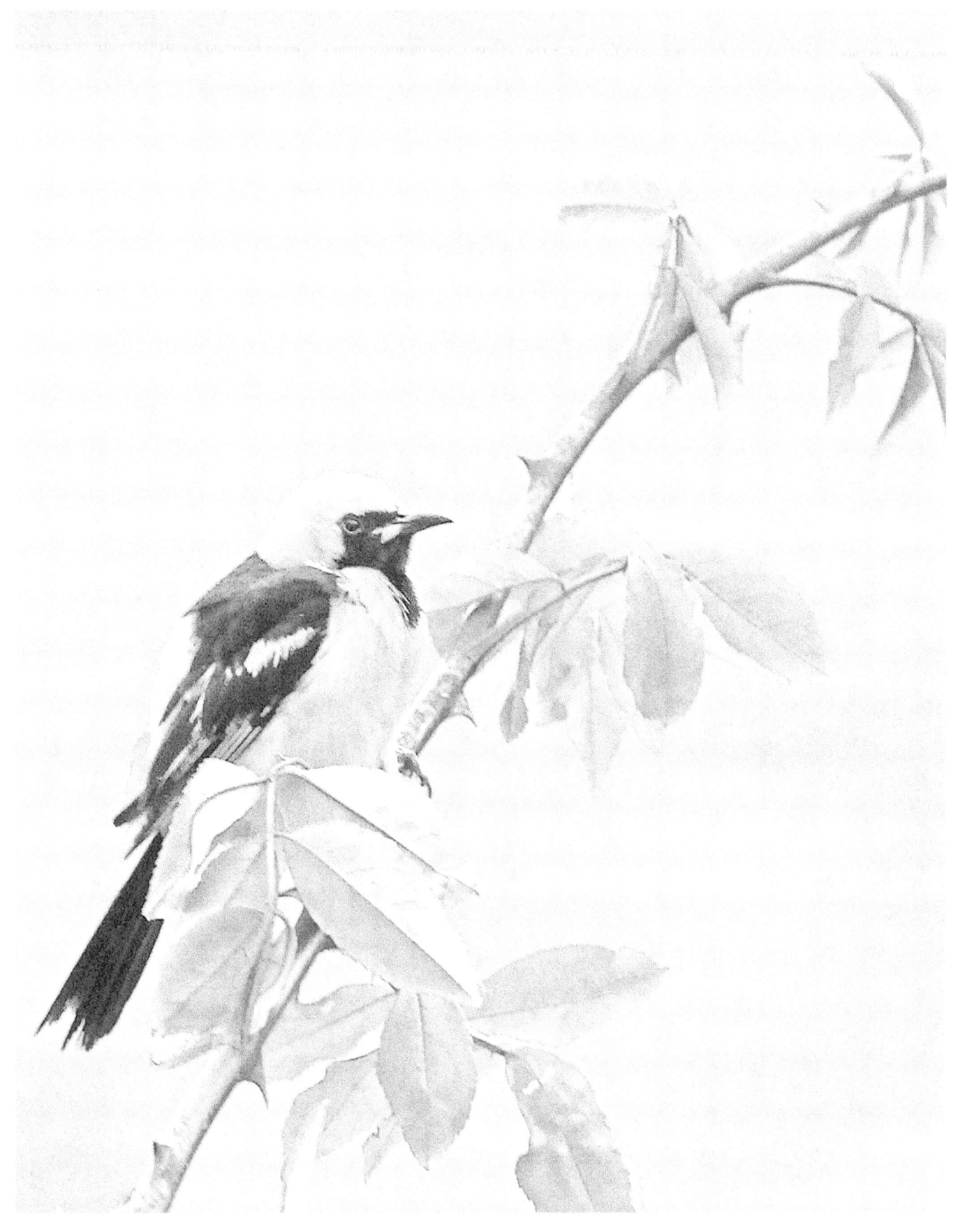

Hooded Oriole (male)

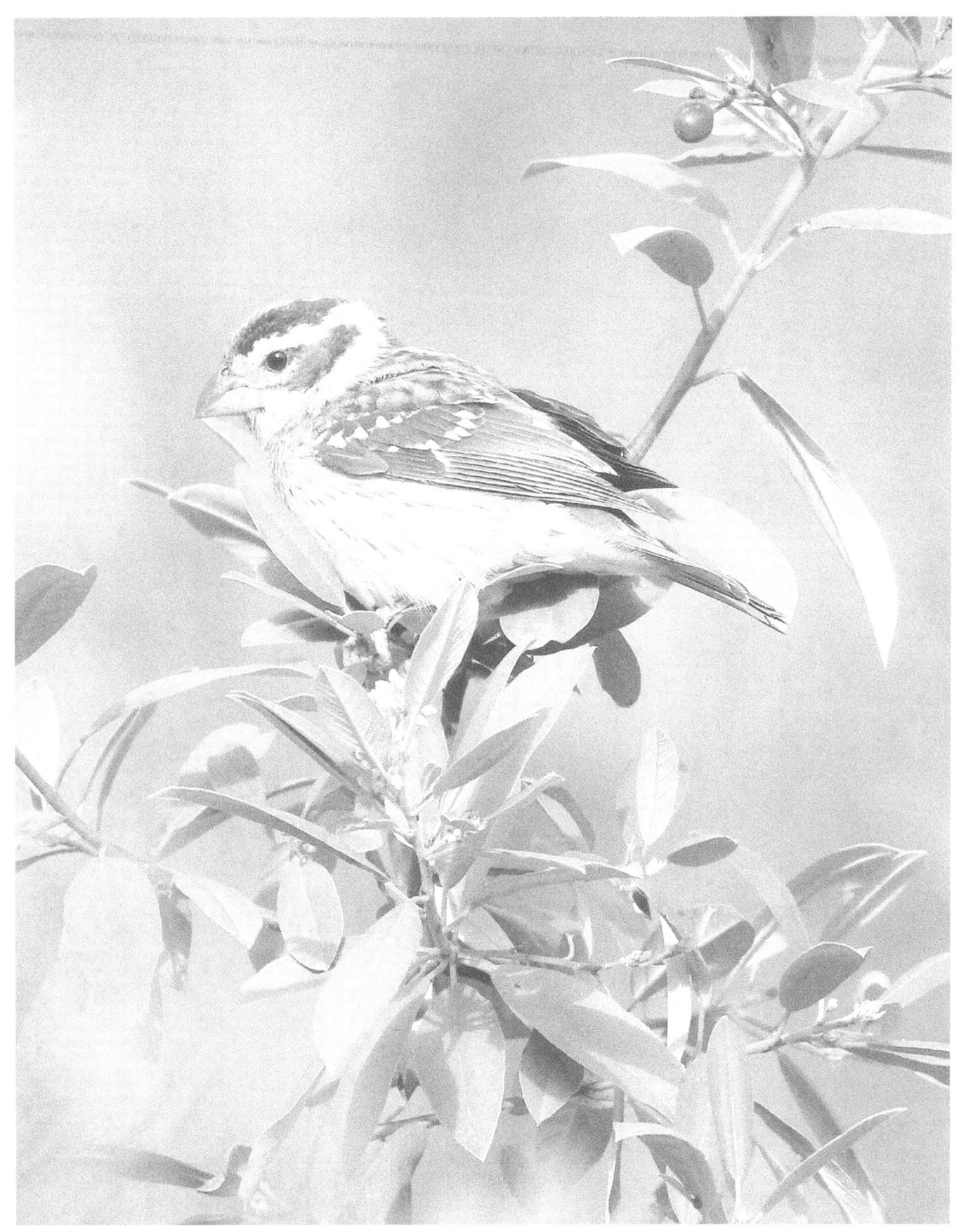

Black-headed Grosbeak

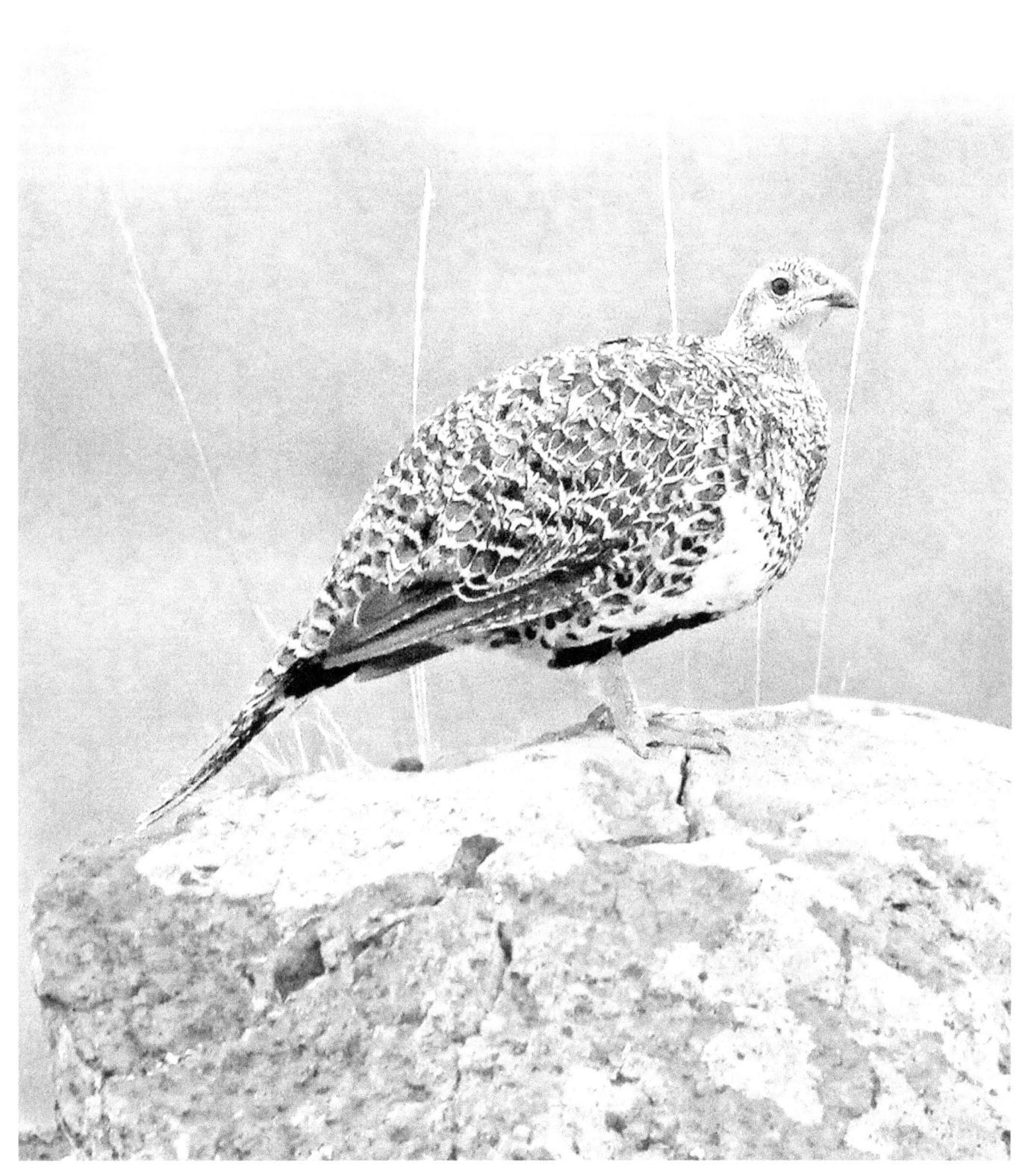

Greater Sage-Grouse

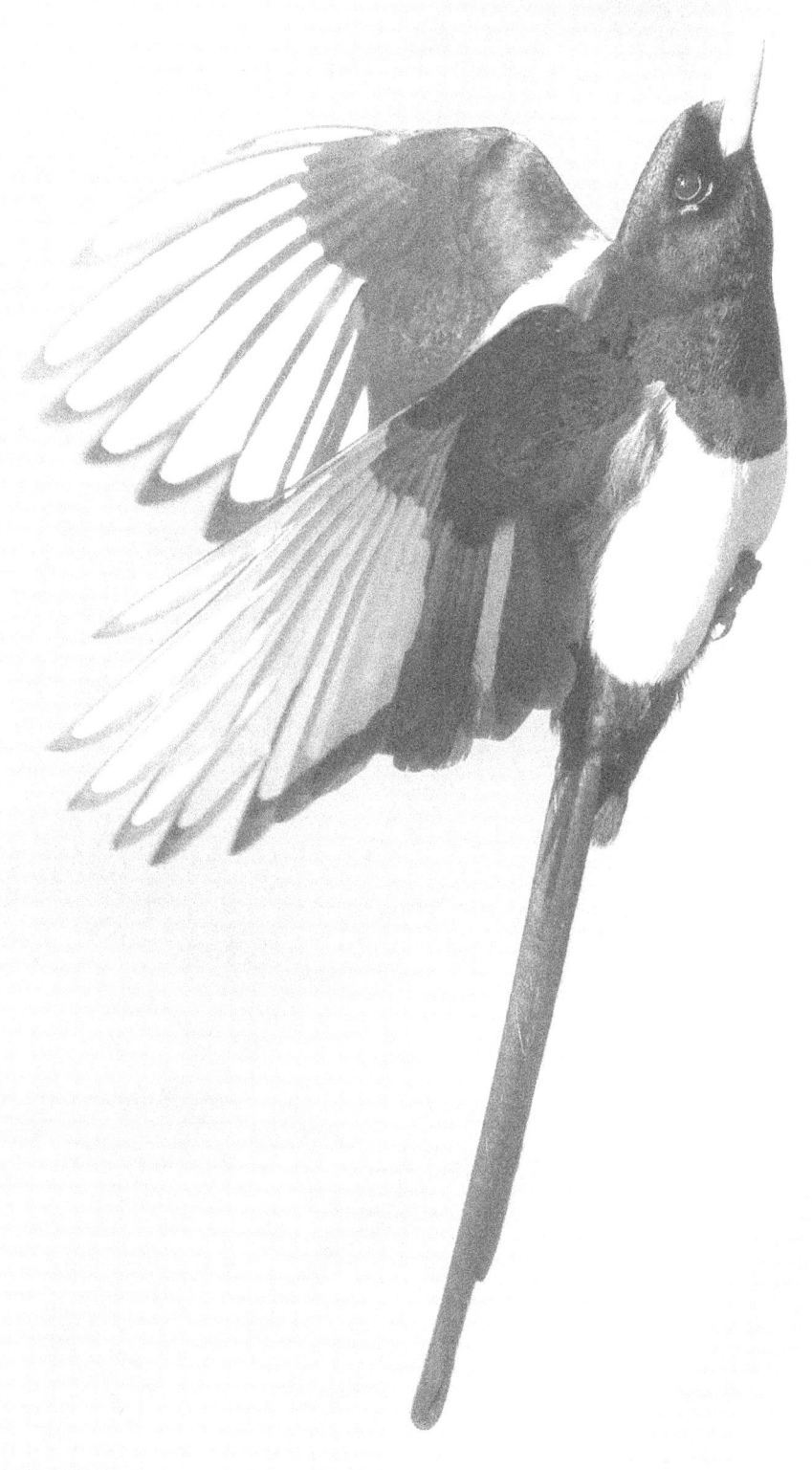

Yellow-billed Magpie

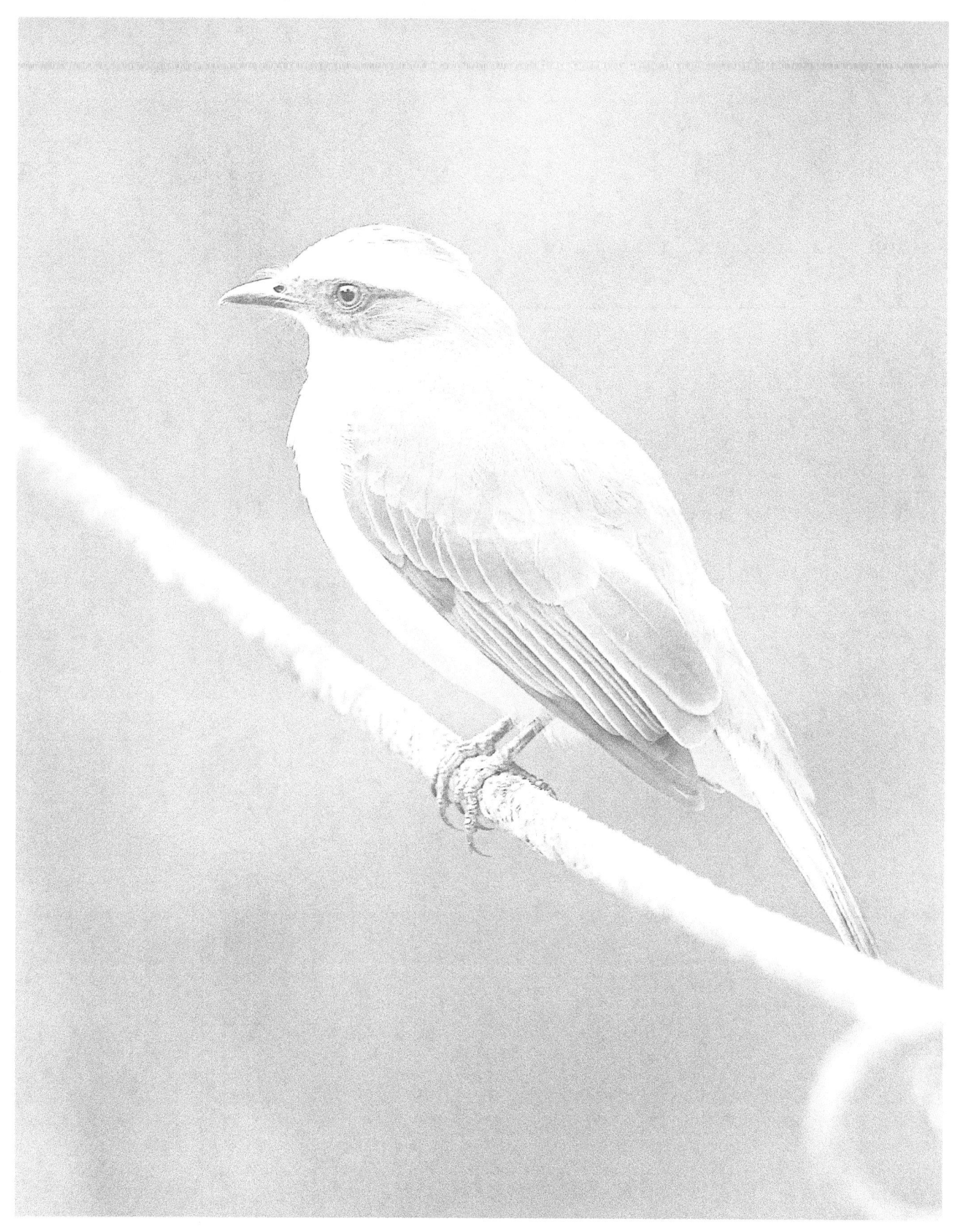

White-ringed Flycatcher

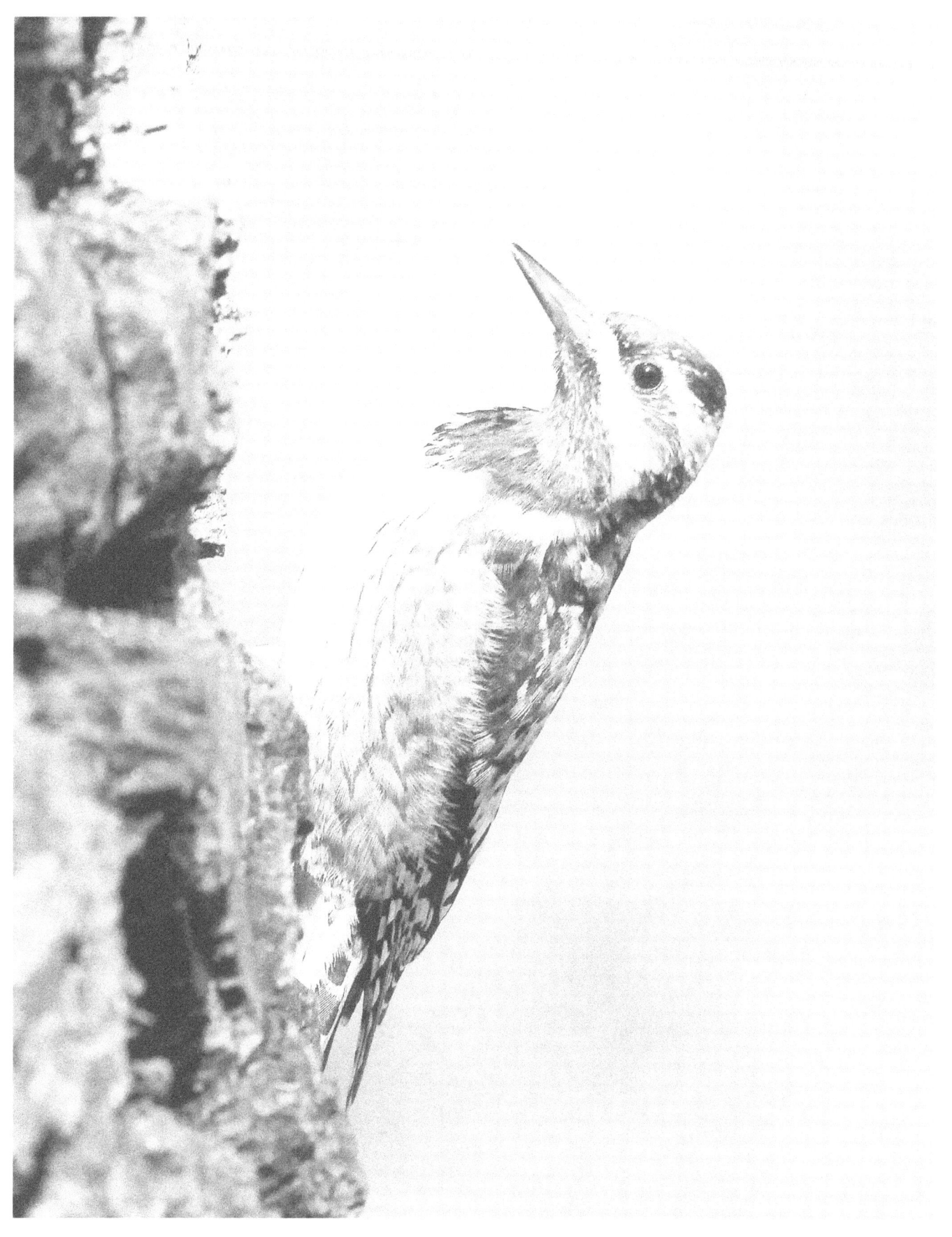

Yellow-bellied Sapsucker

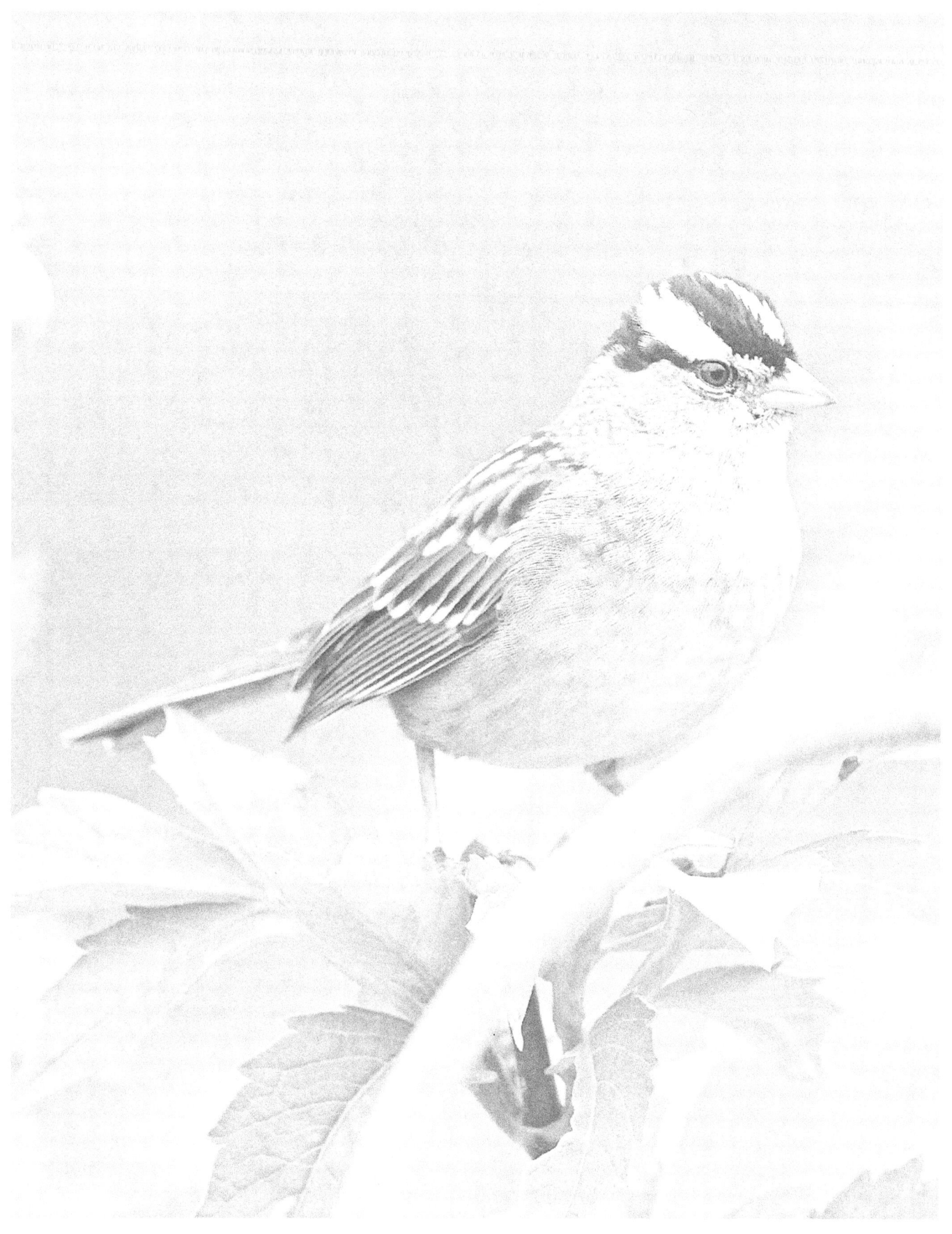

White-crowned Sparrow

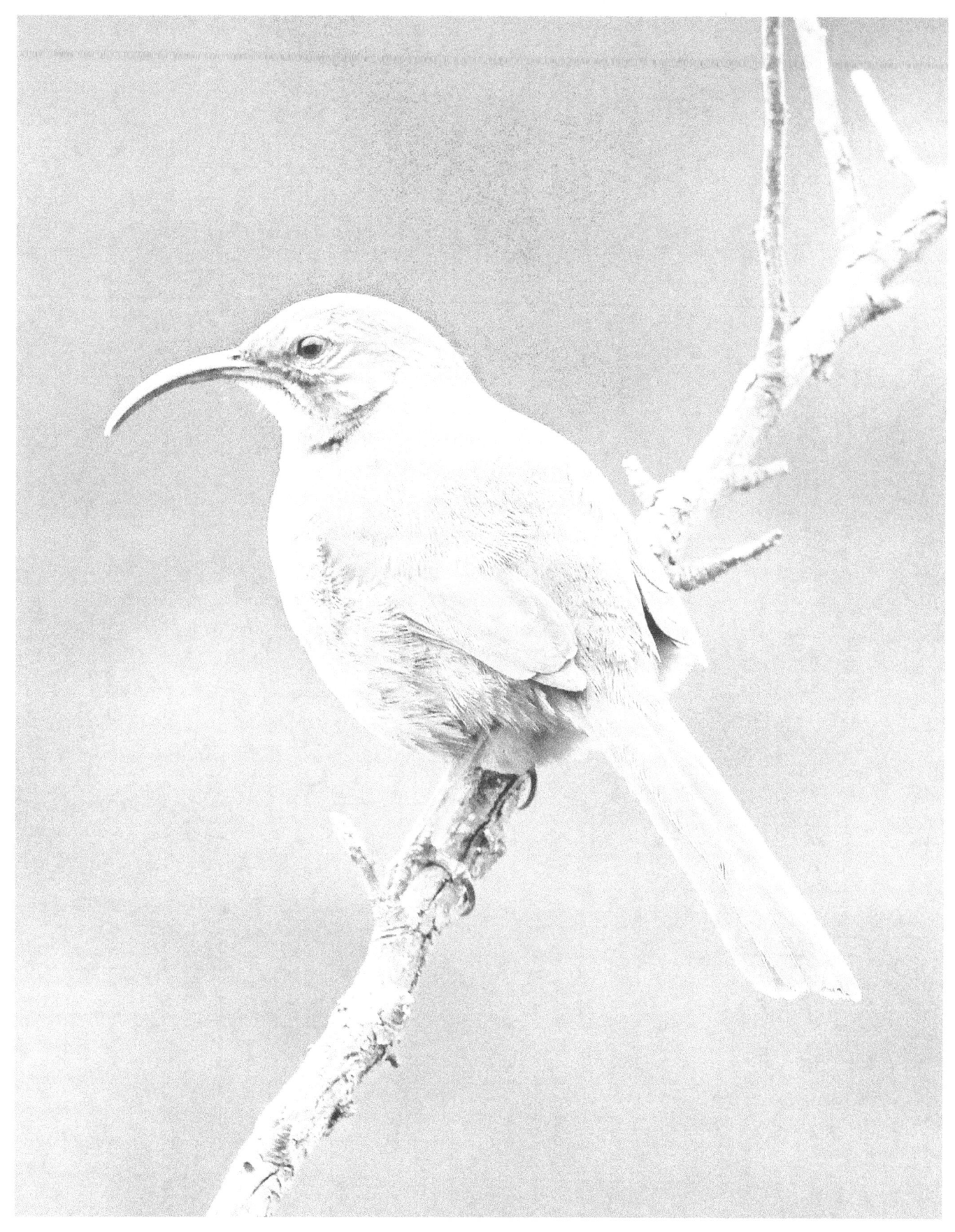

California Thrasher

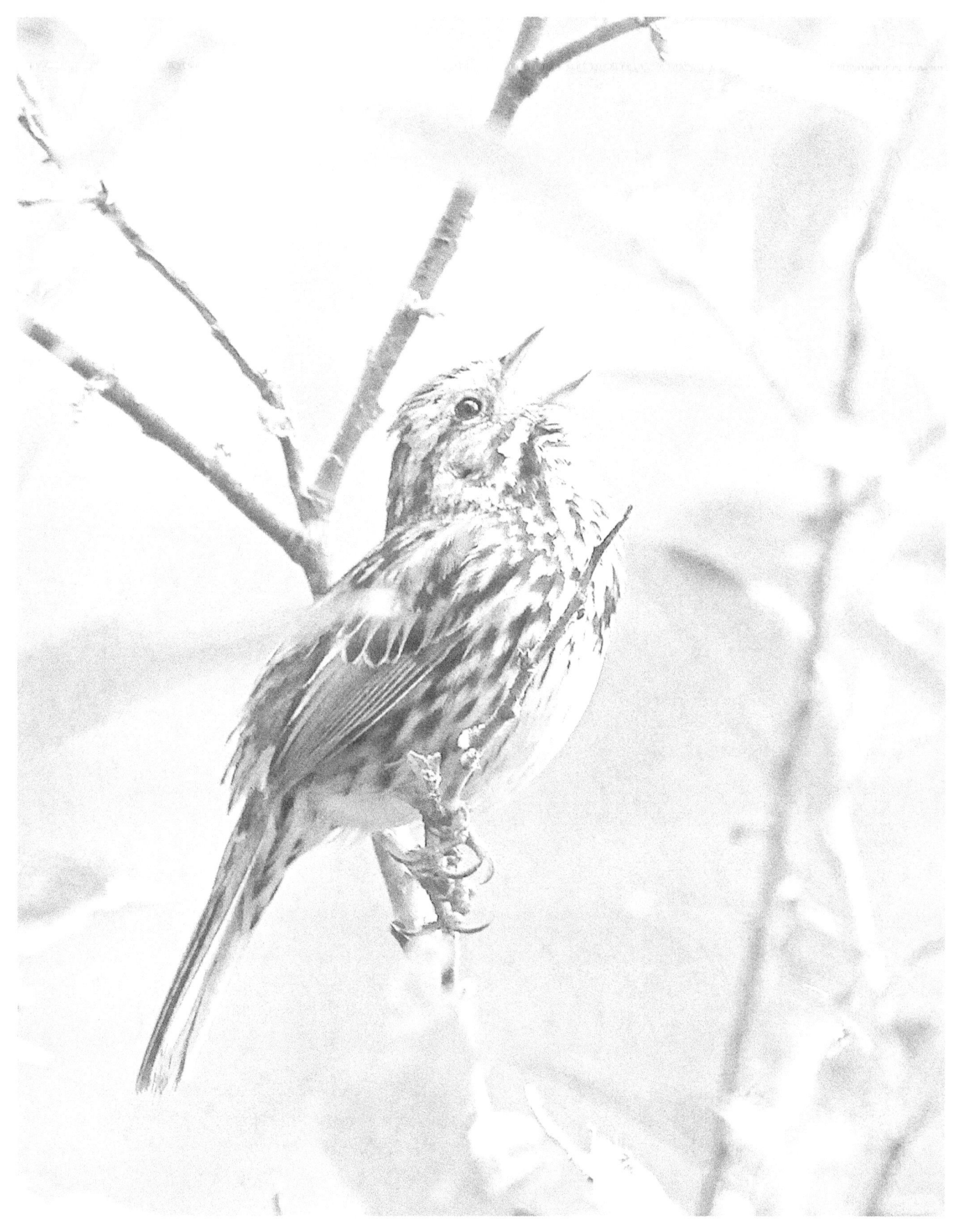
Song Sparrow

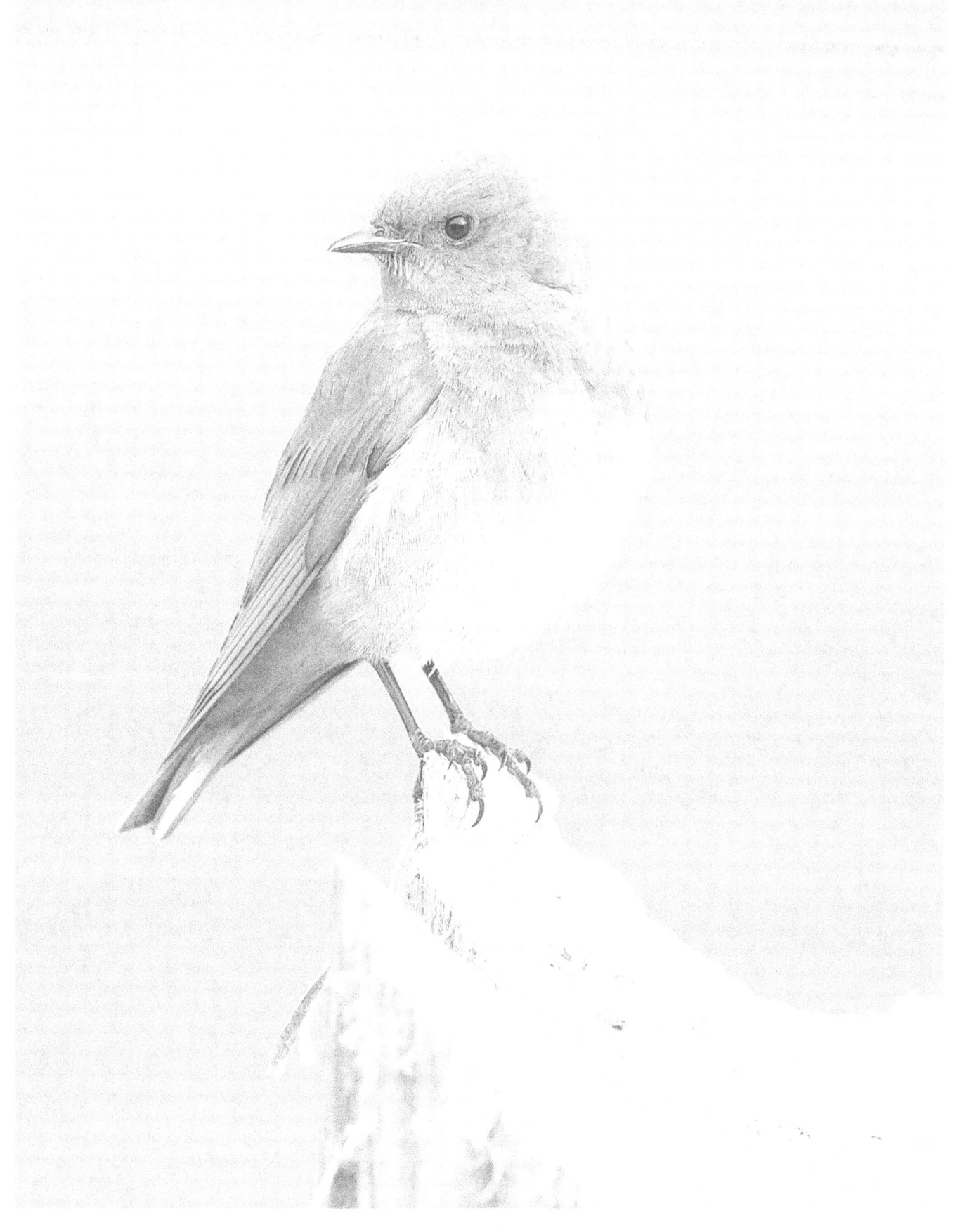

Western Bluebird

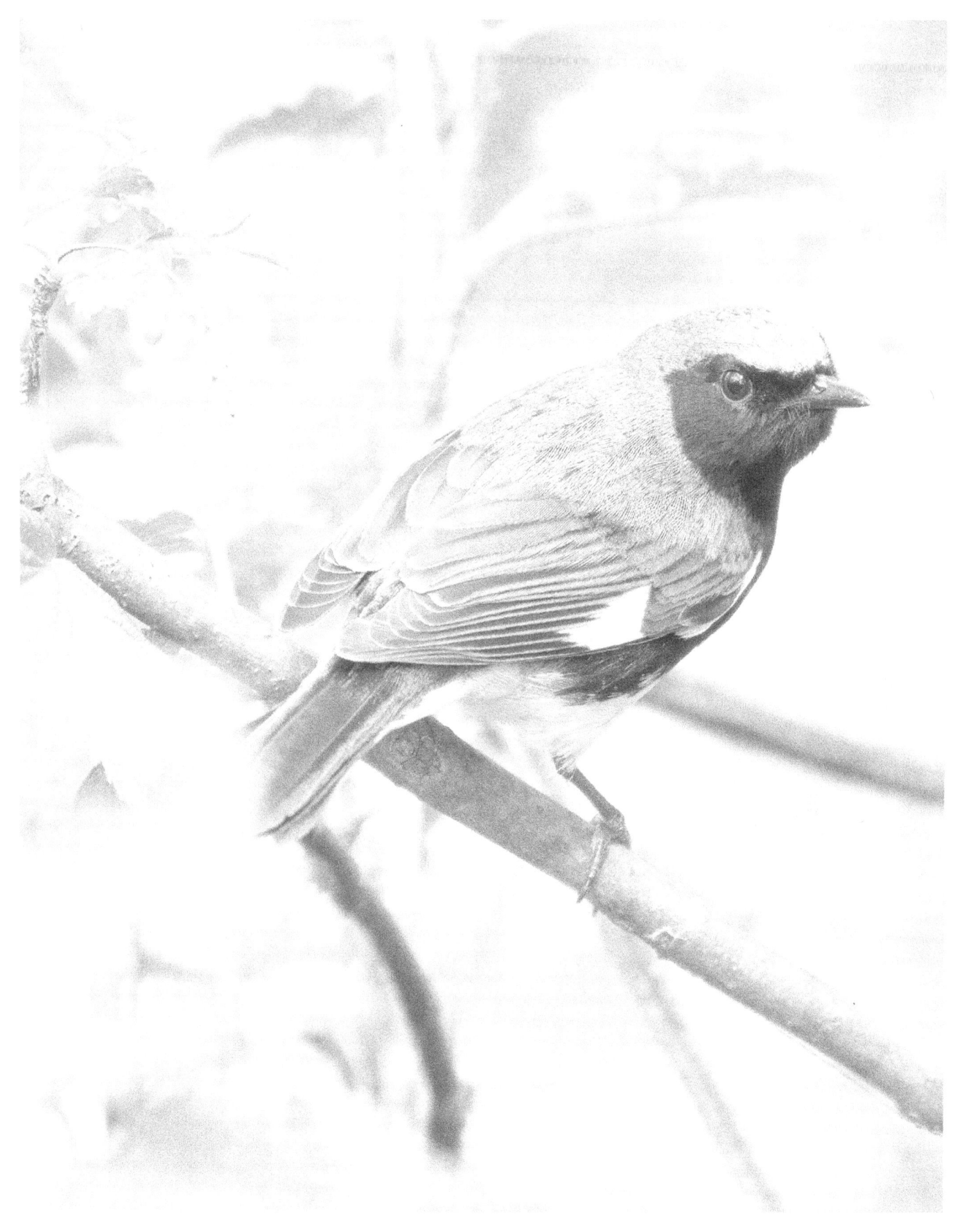

Black-throated Blue Warbler

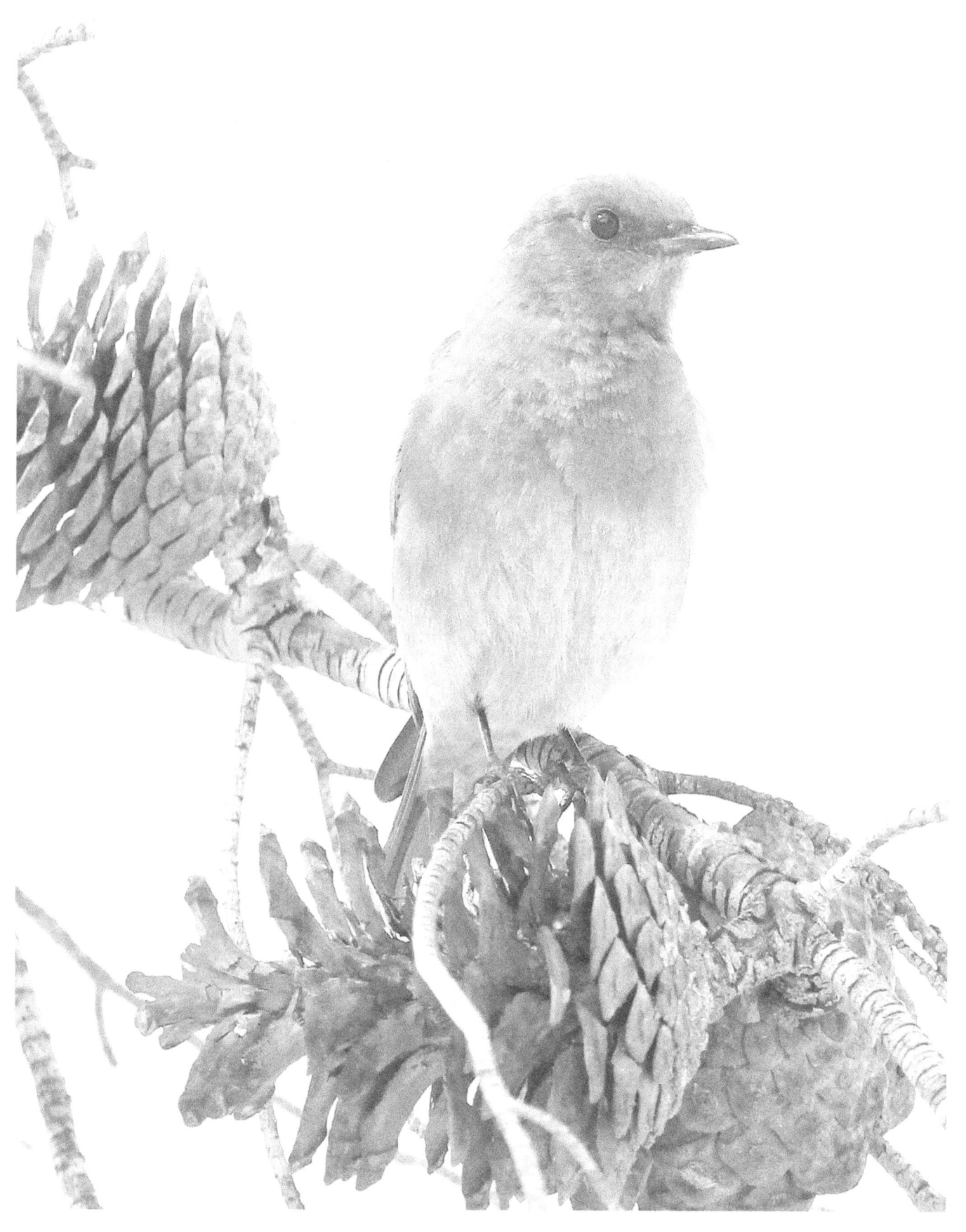

Western Bluebird

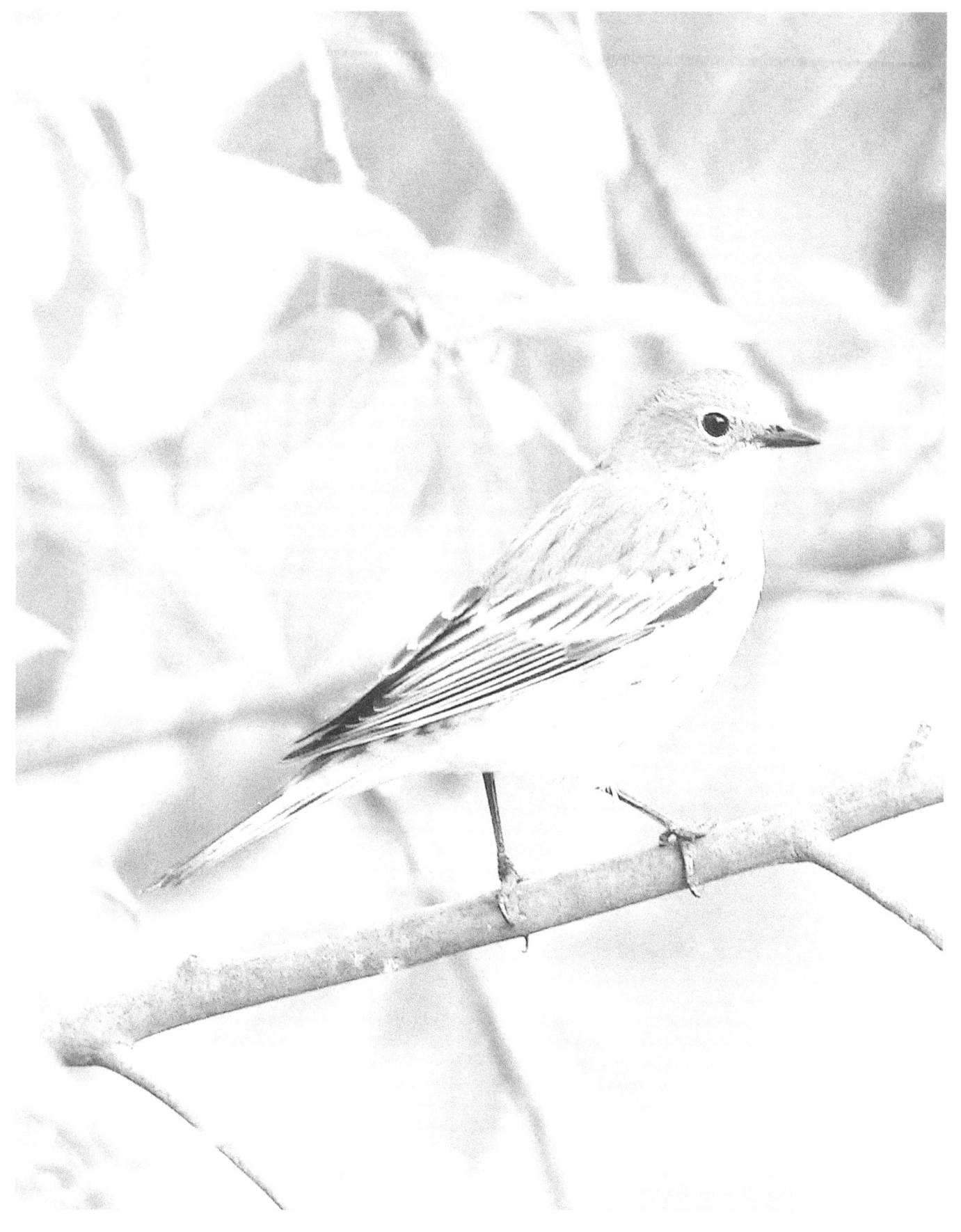
Yellow-rumped Warbler

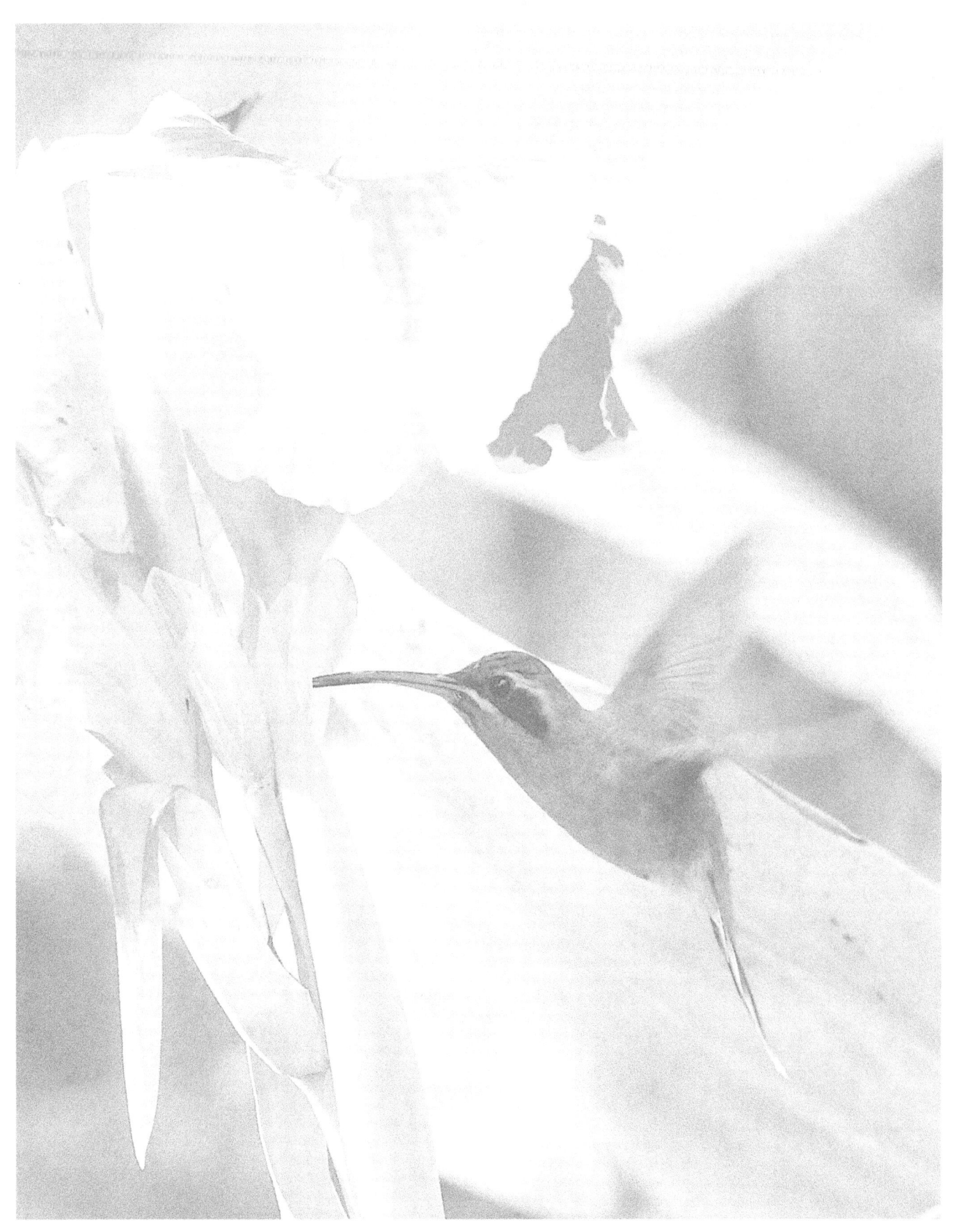

Stripe-throated Hermit

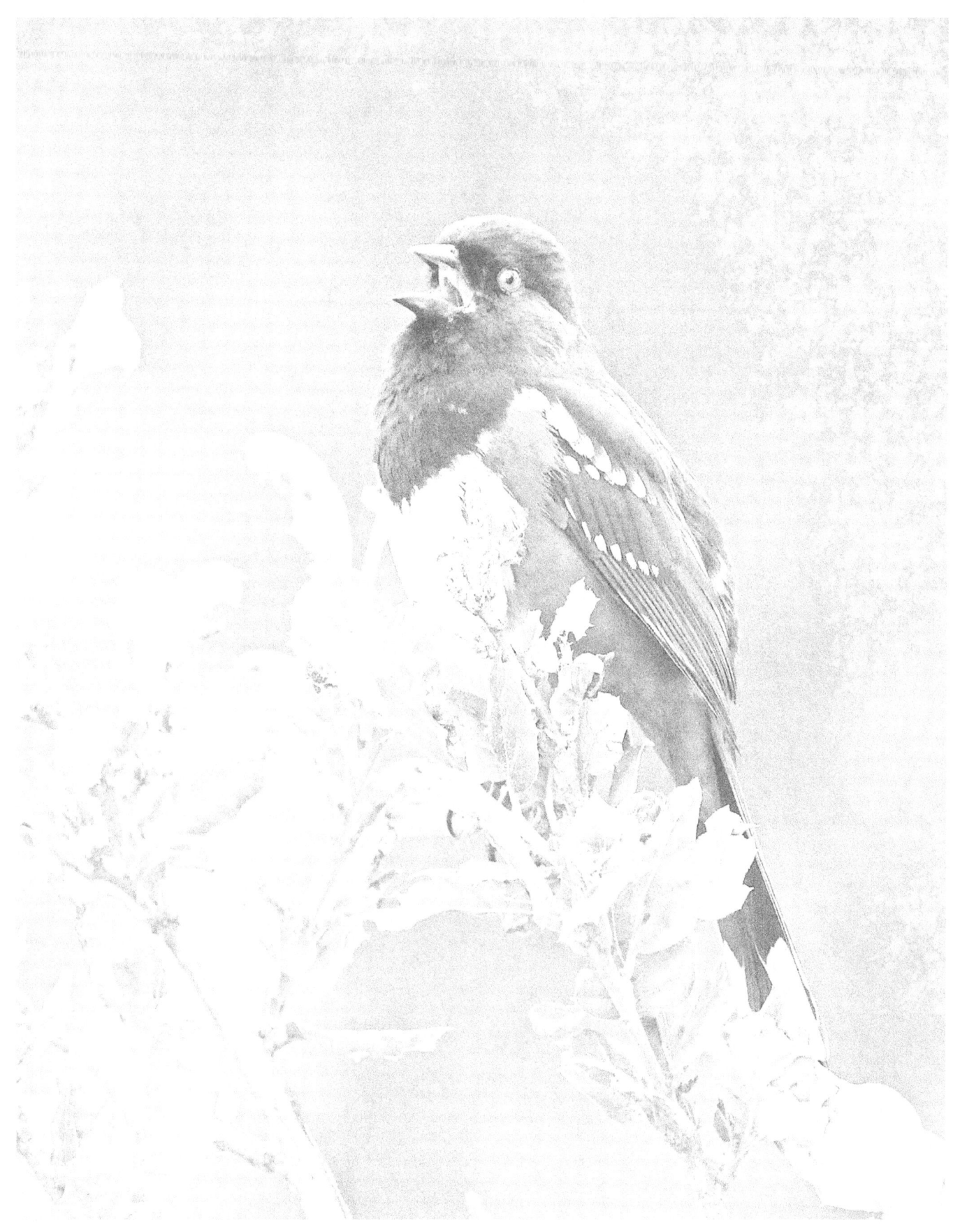

Spotted Towhee

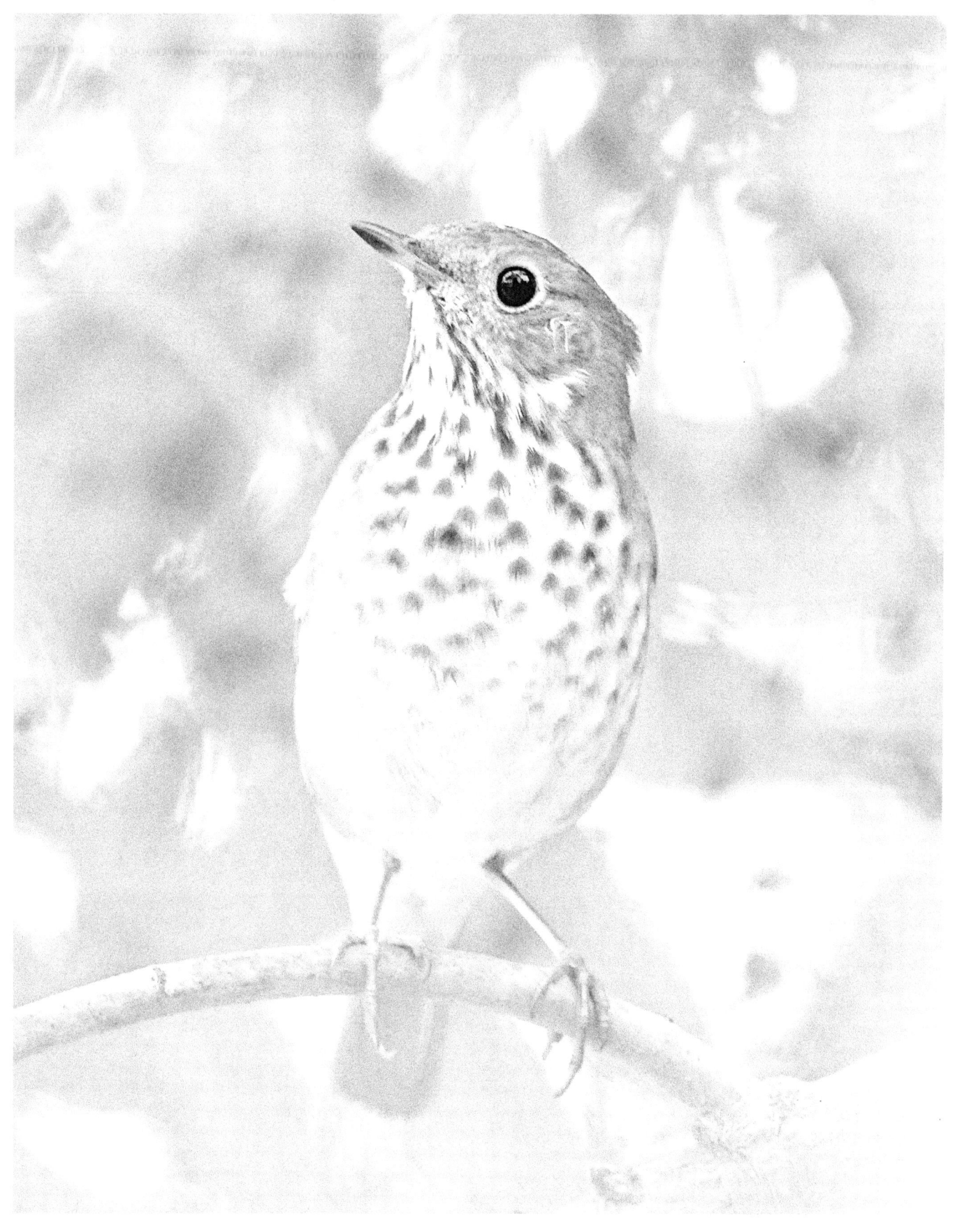

Hermit Thrush

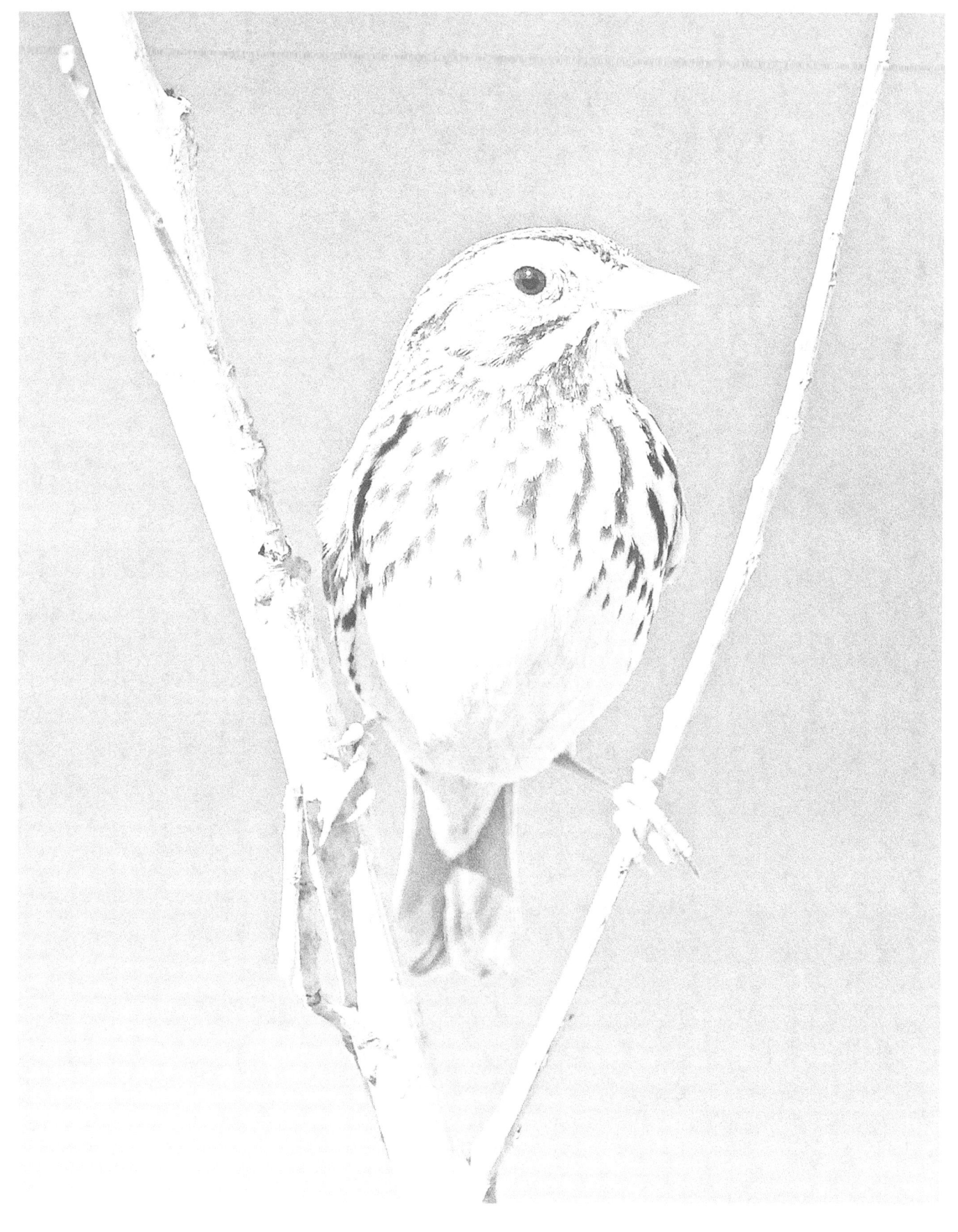

Savannah Sparrow

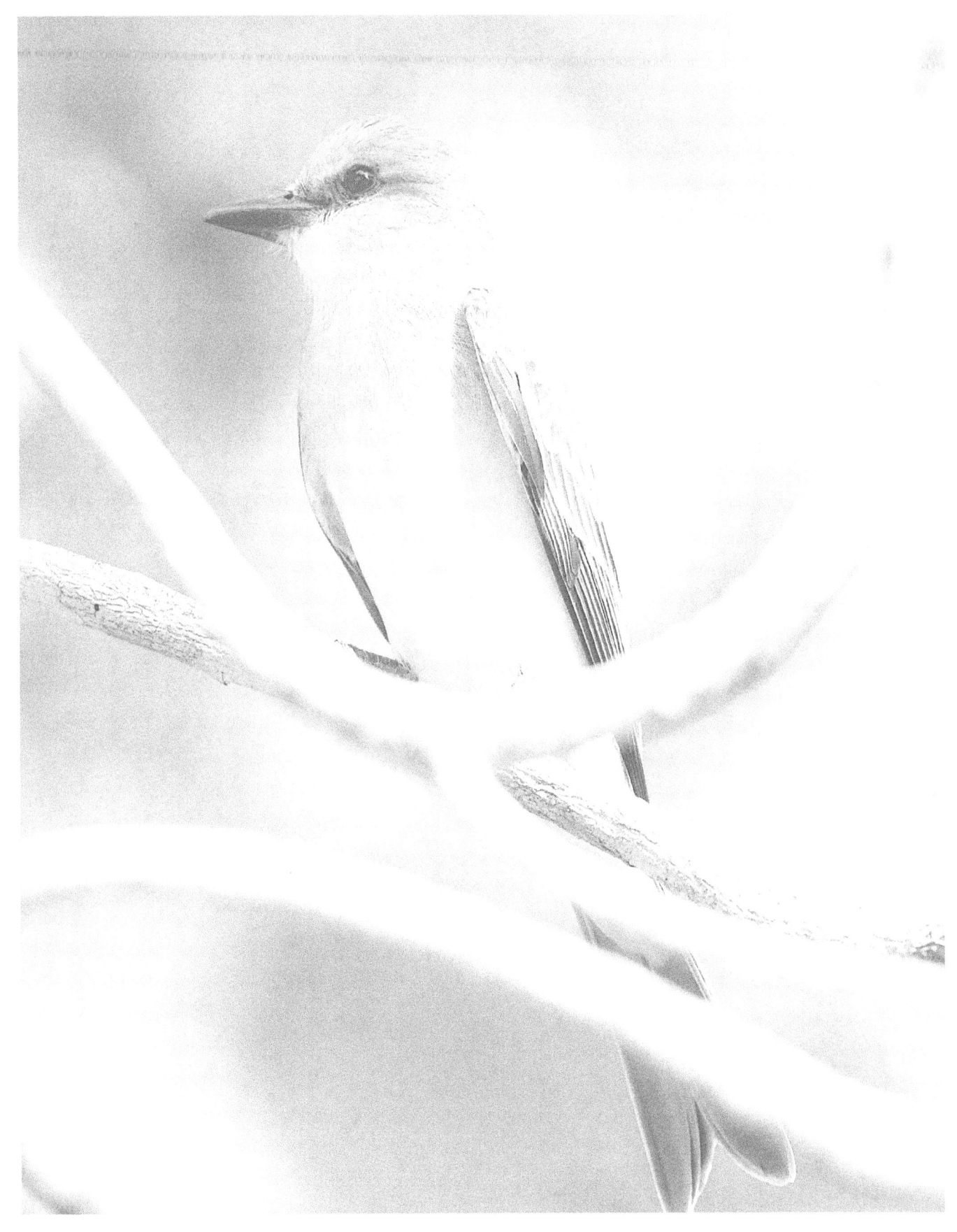

Tropical Kingbird

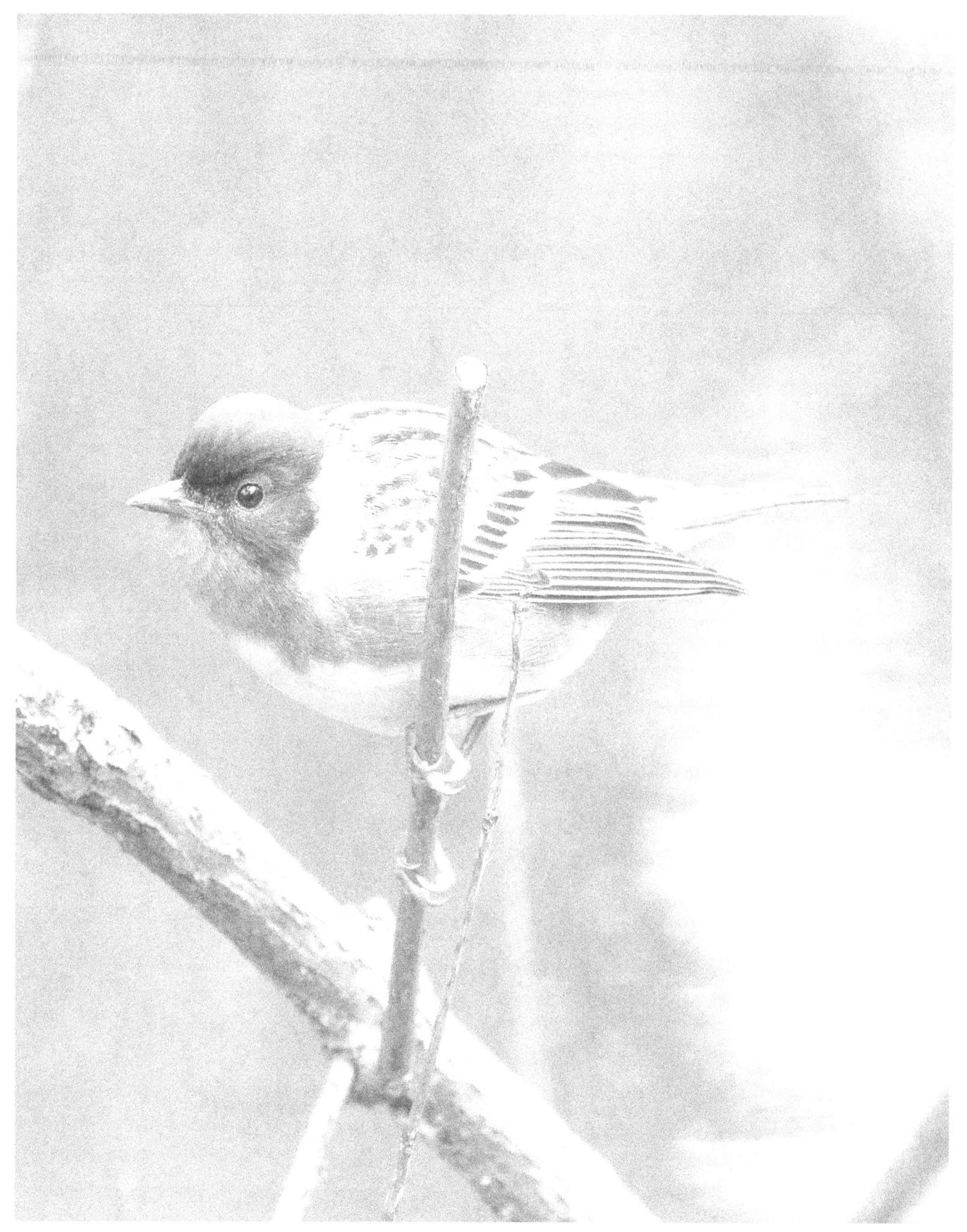

Bay-breasted Warbler

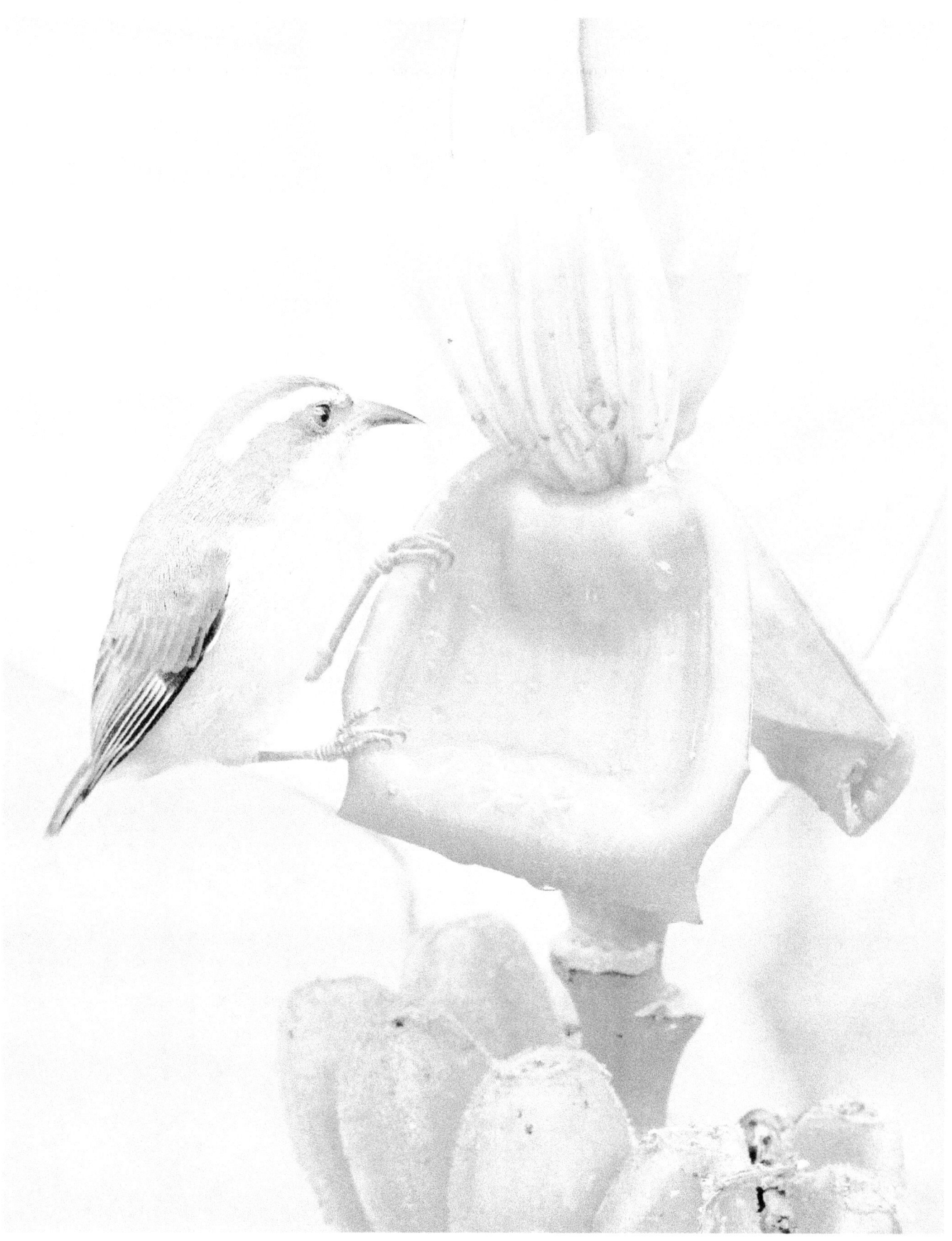

Bananaquit

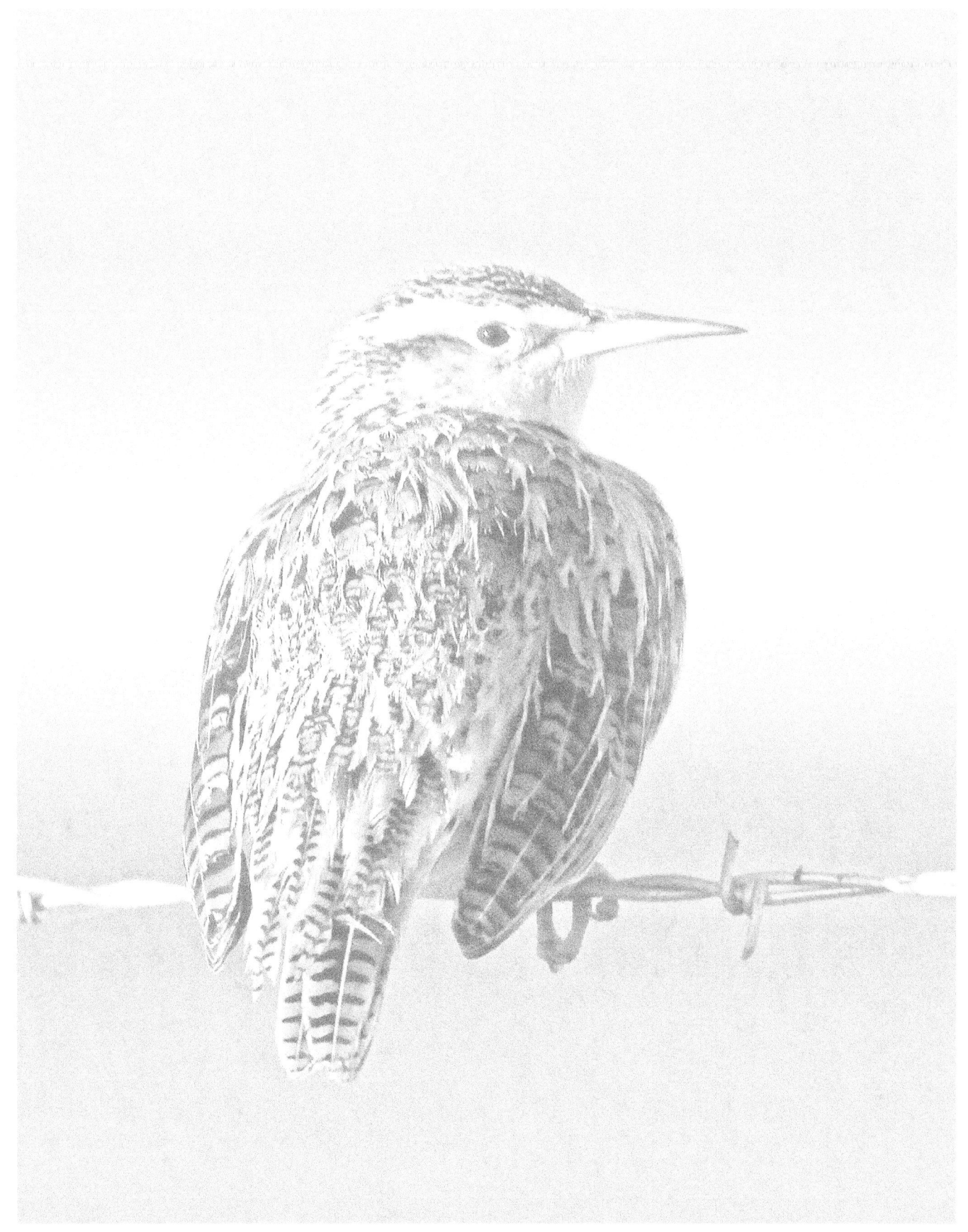

Western Meadowlark

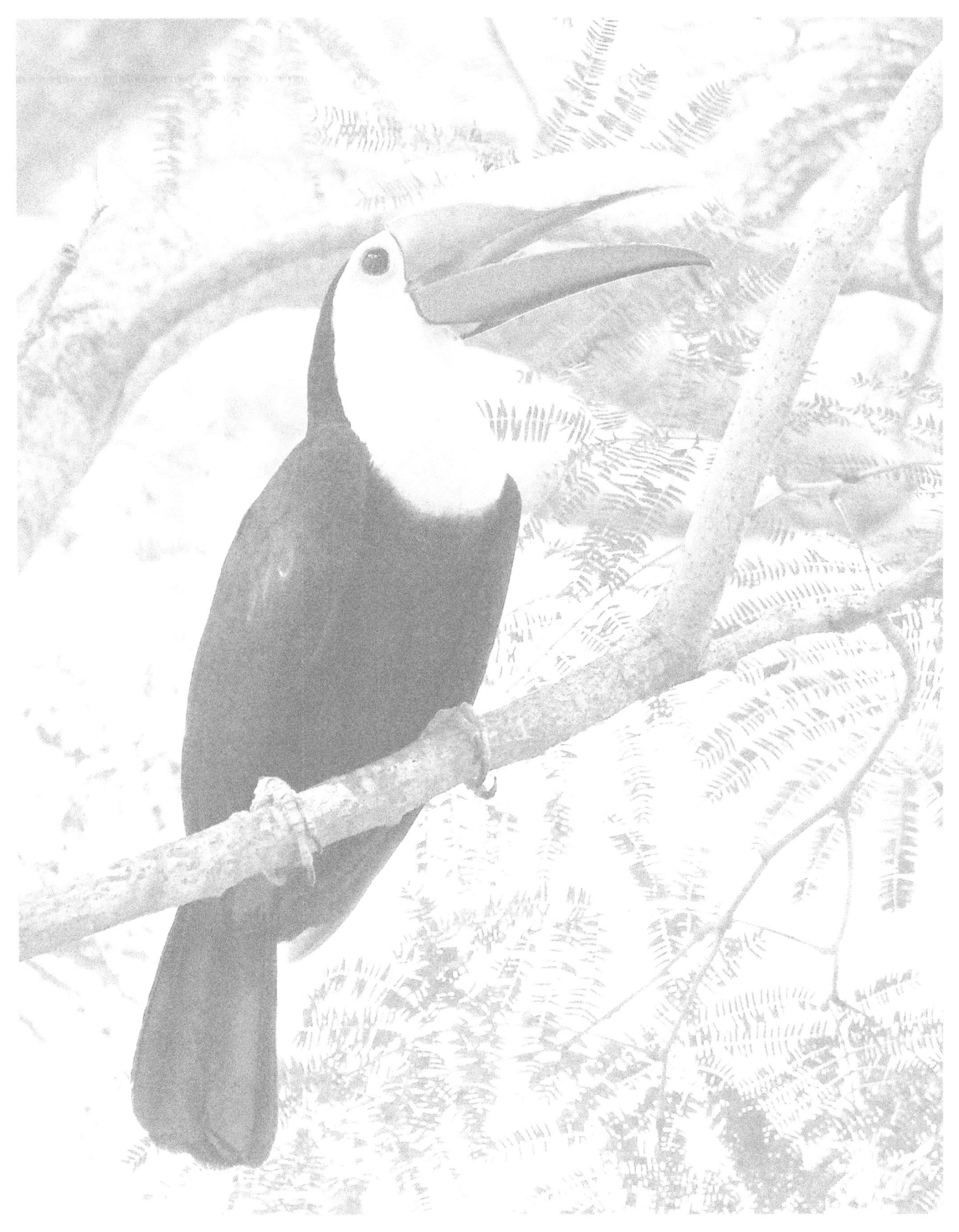

Chestnut-mandibled Toucan

Yellow Warbler

Common Yellowthroat

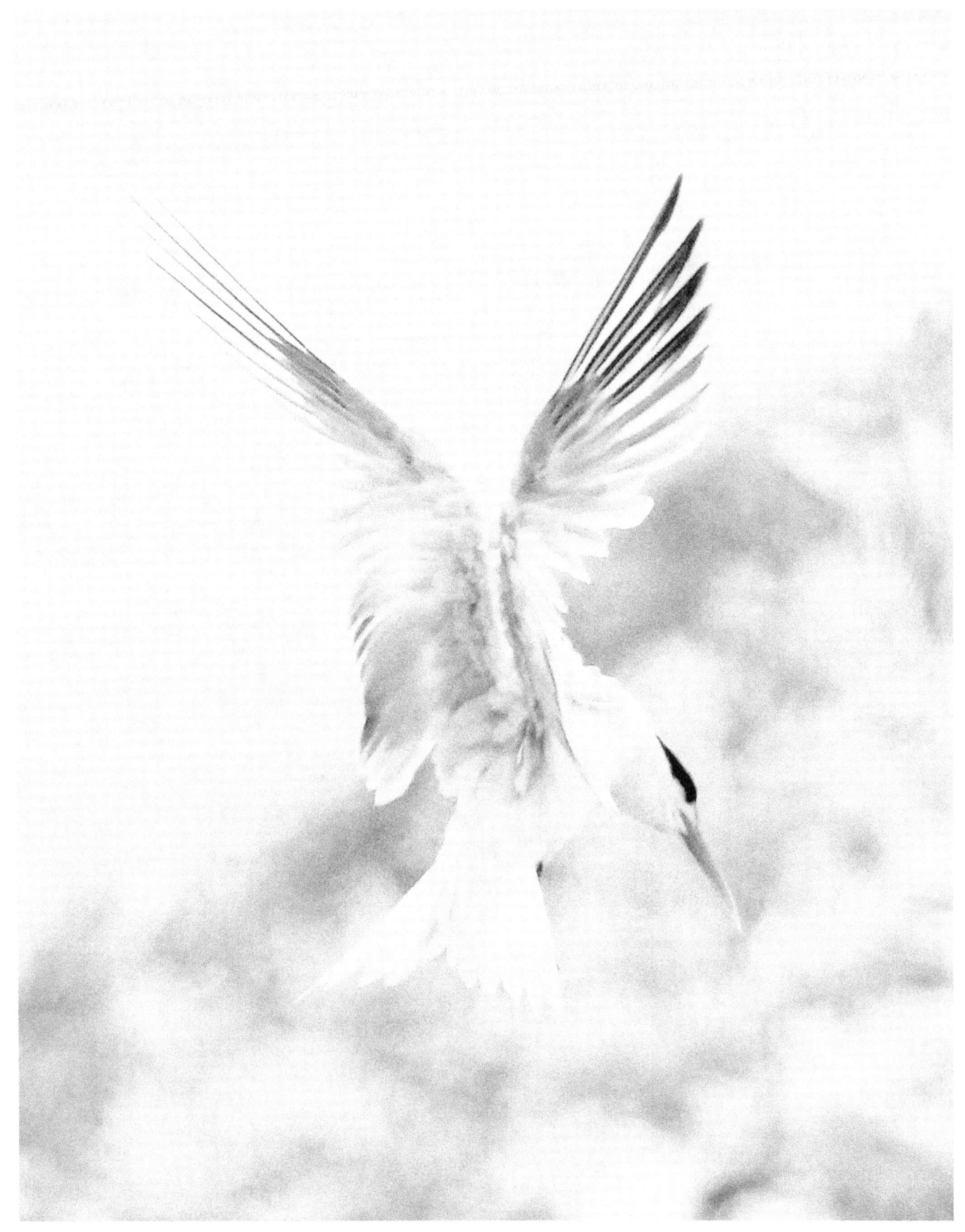

Elegant Tern

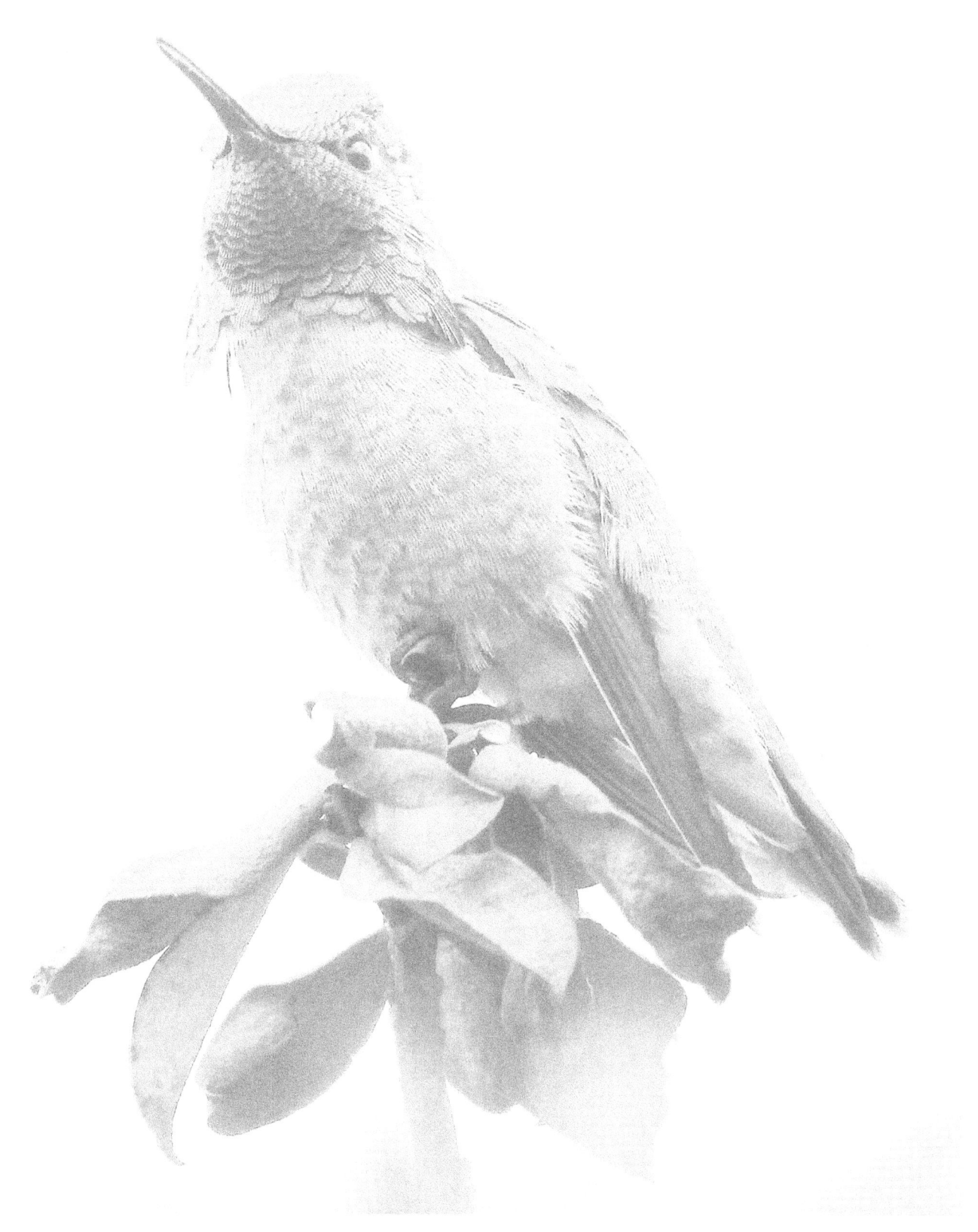

Anna's Hummingbird

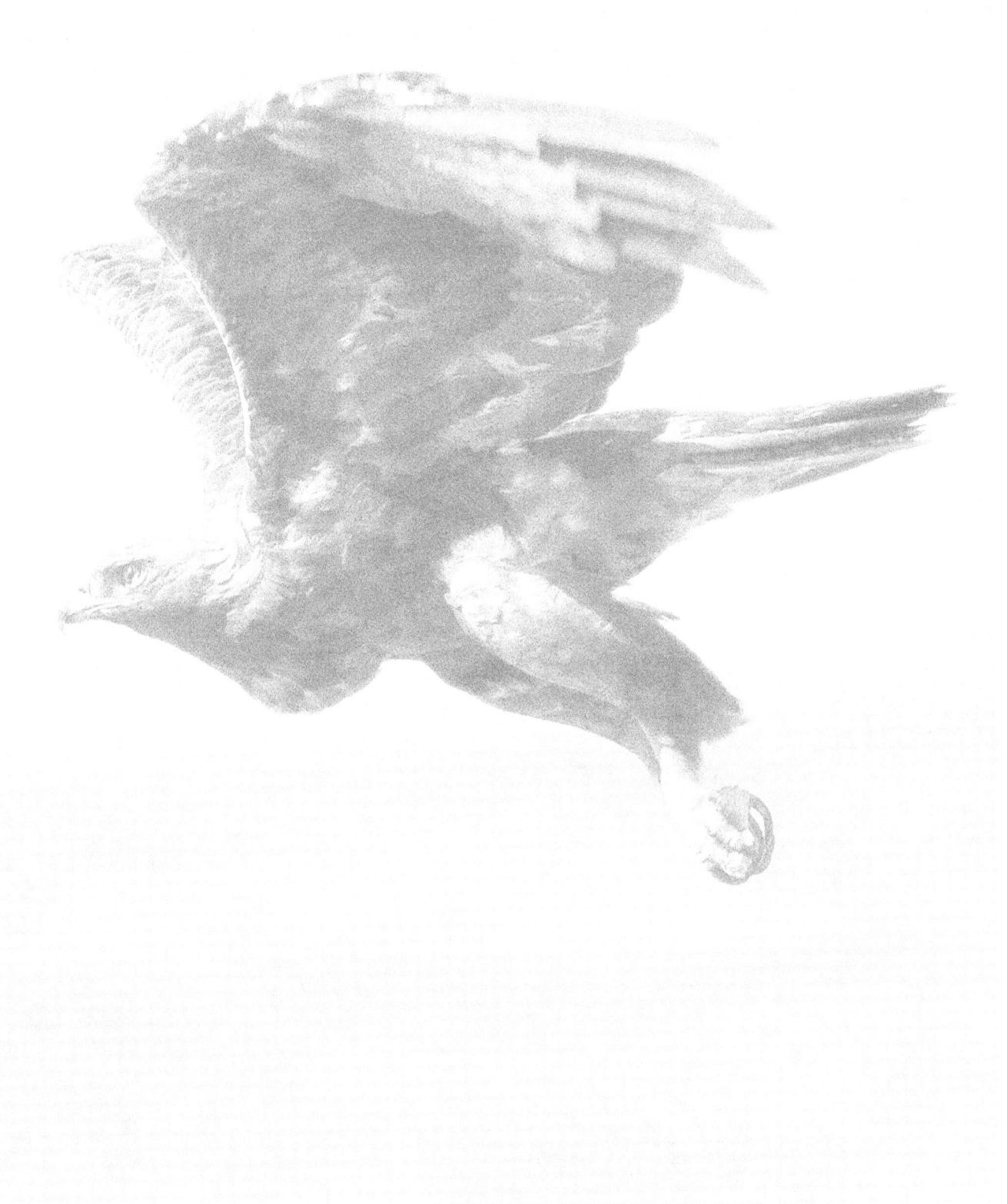

Golden Eagle

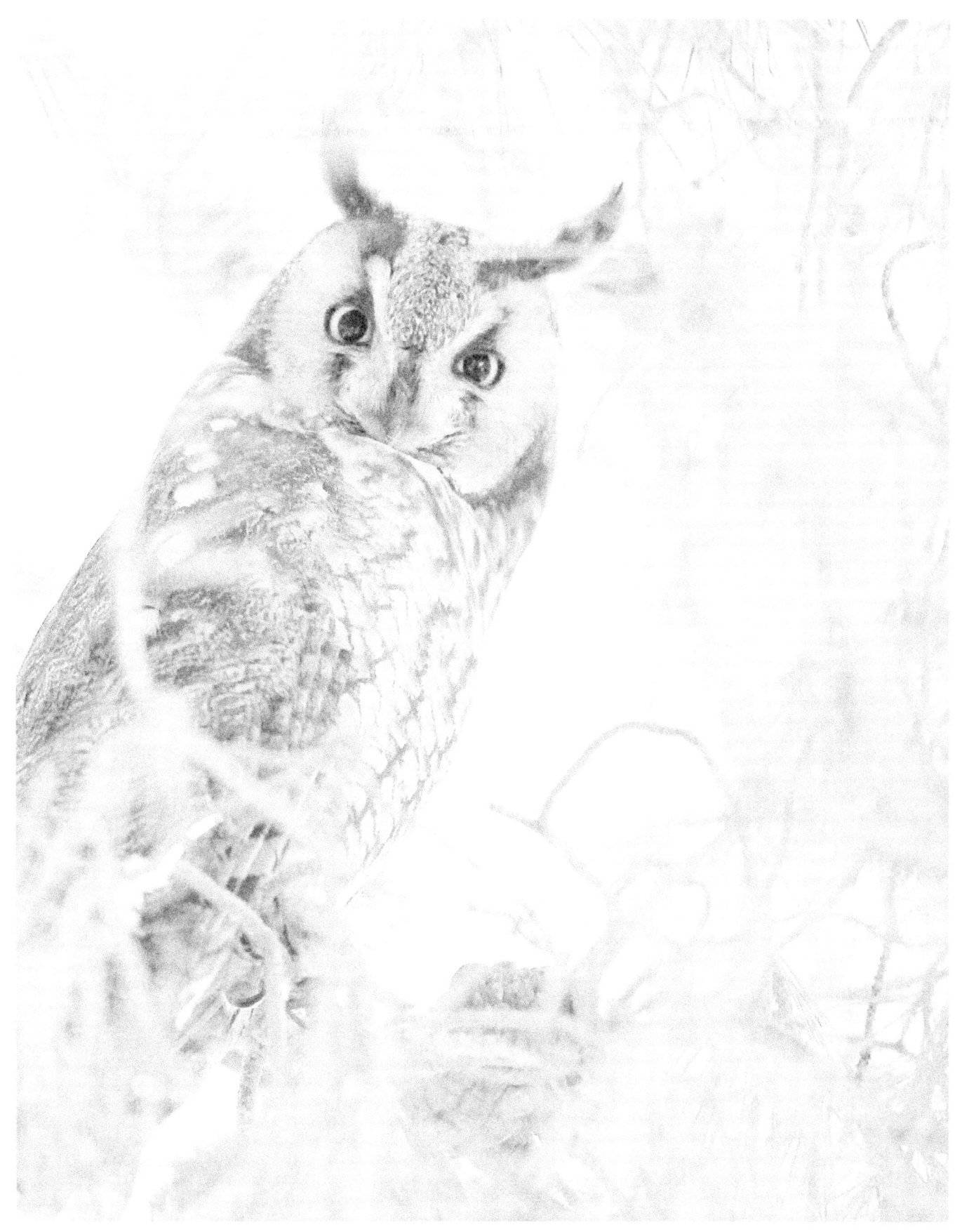

Long-eared Owl

www.ingramcontent.com/pod-product-compliance
Lightning Source LLC
Chambersburg PA
CBHW080229180526
45158CB00008BA/2306